LEGENDARY

OF

ROME

GEORGIA

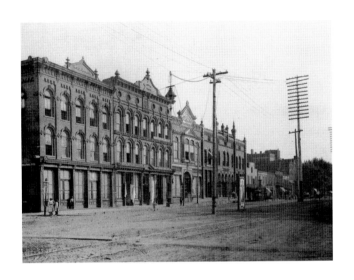

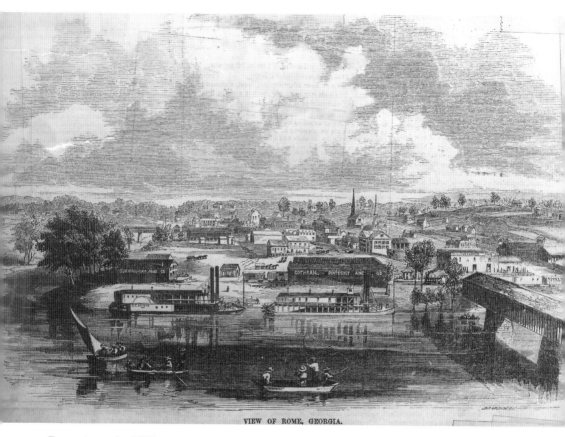

VIEW OF ROME, GEORGIA.

Downtown in 1856
This sketch was made from Myrtle Hill, showing the fast-growing town in its infancy. It was included in *Ballou's Pictorial Drawing Room Companion* on November 1, 1856. Its detail is very accurate. (Courtesy of the Rome Area History Museum.)

Page 1: Broad Street in 1890
This 1890 photograph looks south from the corner of Third Avenue and Broad Street. After over 100 years, this part of Broad still looks much like it did back then. (Courtesy of the Rome Area History Museum.)

LEGENDARY LOCALS

OF

ROME

GEORGIA

ROME AREA HISTORY MUSEUM

Russell McClanahan, Editor

Copyright © 2014 by Rome Area History Museum
ISBN 978-1-4671-0171-4

Legendary Locals is an imprint of Arcadia Publishing
Charleston, South Carolina

Printed in the United States of America

Library of Congress Control Number: 2014934524

For all general information, please contact Arcadia Publishing:
Telephone 843-853-2070
Fax 843-853-0044
E-mail sales@arcadiapublishing.com
For customer service and orders:
Toll-Free 1-888-313-2665

Visit us on the Internet at www.arcadiapublishing.com

Dedication
To Nim Russell and George Pullen, two living legends of Rome who sadly and suddenly left us too soon in 2014

On the Cover: Clockwise from top left:
Predetha Thomas, pioneer educator, with pupils (Courtesy Wyatt Collection; see page 92), Robert Wyatt, at the grave of Almeron Shanklin in France, 1918 (Courtesy Rome Area History Museum; see page 121), Gardner and Jean Wright, local business leaders (Courtesy Gardner Wright; see page 66), Bertha Hill, convicted murderer (Courtesy Mike Ragland; see page 107), Benjamin Neely and the Rome High School faculty in 1887 (Courtesy Floyd County Board of Education; see page 63), Thelmus McRay, killed in World War II (Courtesy the McRay family; see page 124), Alfred McLaughlin, Medal of Honor recipient (Courtesy Marine Corps League; see page 122), Isabel Gammon, society editor of *Rome News-Tribune* (Courtesy *Rome News-Tribune*; see page 106), J.W.H. Underwood, judge and congressman (Courtesy Cathy Dollar; see page 35).

On the Back Cover: From left to right:
Mary T. Banks, with her pupils (Courtesy Wyatt Collection; see page 66), a young Wright Bagby (center), Rome's second mayor, and John Bennett (left), longtime city manager, are pictured with Robert Payne, who was for many years associated with Rome Seed and Feed. (Courtesy Wyatt Collection; see page 31).

CONTENTS

ACKNOWLEDGMENTS

The Rome Area History Museum would like to thank all the past and present local historians, such as George M. Battey, Roger Aycock, John L. Harris, Johnny E. Davis, Mike Ragland, Morrell Darko, Selena Tilley, Shirley Kinney, Pat Millican, and Ann Culpepper, to name only a few. This book would not have been possible without the help of the *Rome News-Tribune* and its predecessors. Special thanks to the Mooney family for permission to use articles and images from the *Rome News-Tribune*. The Wyatt family has provided the foundation of the museum's collection with their generous donation of the former McClellan's store building to house the museum. The anchor of our present archives is the C.J. Wyatt Collection, consisting of photographs and documents that Dr. Wyatt collected over a period of 80 years or more.

Thanks to the board members, especially Hank Adams, who serves as our chairman for 2014, and to the museum founders, C.J. Wyatt, Bobby and Tere McElwee, John Carruth, Ed Byars, and David Oswalt. We thank the many volunteers who have helped with the museum and this book, including Johnny Davis, Dennis Nordeman, and Nancy Smith. Thanks to Joe Smith, Rome city clerk, and Phil Hart, Floyd County court administrator, for providing facts and for their willingness to help. We are grateful for Janet Byington's indomitable spirit in getting things done, and to those who have generously come through during difficult financial times, especially Bernard Neal and Gardner Wright.

There are at least two organizations in Rome that already honor Rome's legends: Redmond Hospital's Heart of the Community organization recognizes those who have given unselfishly back to our community, and the Rome-Floyd Sports Hall of Fame recognizes outstanding athletes in our area. We are grateful to both of these fine organizations for allowing us to use their archives in the printing of this book. Special thanks to Tommy Tatum for his support in editing and doing the table of contents and index. Thanks to Leigh Barba and Donna Shaw, who keep the museum running, and especially to my wife, Stephanie, and children Rhiannon, Trace, Billie Ann, and Rebecca Jane for their support and patience in the writing of this book.

All images appear courtesy of the Rome Area History Museum unless noted as follows: the *Rome News-Tribune* (RN-T), George Magruder Battey's *History of Rome and Floyd County* (GMB), and the Rome-Floyd Sports Hall of Fame (RFSHF).

The author is grateful to all prior historians of Rome and Floyd County whose works serve as a foundation for this volume, including George Magruder Battey, Roger Aycock, Lavada Dillard, Frank Barron Jr., Morrell Darko, Jerry Desmond, Dr. C.J. Wyatt, and writers for the *Rome News-Tribune*.

INTRODUCTION

For over 8,000 years, the juncture of three rivers has felt the footsteps of mankind, and for only a short period is there an historic record for this area. That record began in 1540, when Hernando DeSoto brought his band of over 600 through this region, wreaking havoc with the locals and leaving disease and confusion in his wake. Fortunately, he had several scribes with him who wrote down for future generations the first historical record of this area. Who knows what legends of mankind preceded him here? What heroic feats of mankind or acts of self-sacrifice occurred on or near the riverbanks of what is now our home? And, truly, this is our home, the people whose families who have been here for generations, who have just recently arrived to make a life here, or folks just passing through who are mesmerized by the beauty of the hills and the rivers. These people make Rome what it is: home.

According to Calder Willingham in *Eternal Fire*, "In this peaceful land, pretty birds sing and the woodbine twines. Violets and forget-me-nots bloom in the meadow. The wind is soft as a baby's smile, and as warm and gentle as mother love. Only an occasional random tornado moils the scene and disrupts nature. True, the summer sun is a fiery furnace; it boils the blood, cooks the brain, and spreads a fever in the bones. But that same fearful orb, in collaboration with the sweet rain generated by its power, makes the little flowers grow.

"Illuminating Spanish moss and great-armed oaks, dawn burst across the golden isles off the southern coast of Georgia and poured like a rosy tide toward the fair uplifted bosom of Dixieland; over the sandy barrens and past the rolling Piedmont toward proud Atlanta, and on beyond, flashing gold light into the red and green hills. Nestled in those slopes lay a patch of jewels at the juncture of two rivers, sprinkled on the earth by a mighty hand. The blue mountains in the distance, serene for ten thousand centuries, looked down through drifting white clouds upon the power of creation."

Thus, we arrive in Rome. Under the microscope of time, we have only been in Rome for a minuscule second, from the time in 1834 when five men dropped names in a hat to determine the name of the settlement they had decided to build at the juncture of these three rivers. No one knows how long the names of the Oostanaula or Etowah have followed these rivers; they are prehistoric names that came with the Native Americans who once lived on them. Since prehistoric times, before the founding of Rome, where the rivers meet was known as the "Head of Coosa," as this is where the Coosa River begins its journey to the sea, later to be joined by the Tallapoosa to form the Alabama River on its journey to the ocean at Mobile Bay.

But for the luck of the draw, we may have been Hillsboro, Pittsburg, Warsaw, or even Hamburg. The name drawn from the hat was Rome, chosen by founder Daniel Mitchell, for the seven hills that surround the site. And that is where our story begins.

These five men who founded Rome are surely legendary for their part in creating Rome as we now know it. But what about the other souls and situations that make Rome what it is? Every person who has walked the streets of Rome has their own perception of who is legendary. To them, it might be the meek and mild boy who stood up to the class bully in third grade, the high school football player who overcame all odds to score the winning touchdown on that cold Friday night under the lights at Barron Stadium. We all have our legends. This book is an attempt to take snapshots in time from the day those men gave a name to our home in 1834 to the beginning of the 21st century.

In this book, we strive to give a sample of some of the folks who make Rome what it is; a culmination of lives, some heroic, some tragic, some living on the edge. Our Rome is the backdrop, the canvas that

so many lives have formed their lives around. This is our attempt to perhaps brighten those shades or tints that color our lives to this day, perhaps to illuminate certain dark spots in the fabric or change the angle so that we can view from another perspective.

Hopefully, this book will bring back some pleasant memories from the past and result in a smile or two, or remind us that, whether pictured with or without our makeup on, it is our community, our spot of earth on the planet, our home.

CHAPTER ONE

Head of Coosa
The Dawn of Time

The confluence of the Etowah River, often referred to as E-tow-wah or Hightower in historic records, and the Oostanaula River is where the Coosa River begins, thus the older term Head of Coosa. The rivers of that time were the main arteries of travel, comparable to the interstates of today. Thus, the Head of Coosa, which is now Rome, was a main intersection that would have been easily identifiable to natives of the prehistoric period.

For over 10,000 years, after Native Americans crossed the Bering Strait, the feet of mankind have struck the ground that we walk today, or canoed the rivers that wash our shore as we read this. Only our imagination can conjure up the countless legends or heroes who gave their lives for their families, lovers, or tribes, especially considering that to survive they had to hunt the buffalo, saber tooth tiger, or bear that roamed this area over the centuries.

It is noted by Charles Colcock Jones, in his studies of antiquities of Georgia, that there was a 50-foot-diameter mound between the rivers at Head of Coosa, with several smaller mounds in the area now covered by Broad Street. At some point, these mounds, which were filled with bones and artifacts of an earlier culture, were cut down and used to fill in the floodplain between the rivers. Thus, the area we call Rome was once part of the highly civilized Mississippian Mound Builder culture, which is linked with the Etowah Indian Mounds and flourished for hundreds of years.

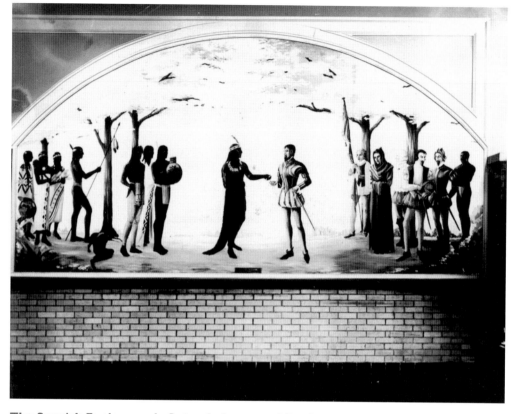

The Spanish Explorers: de Soto, de Luna, and Pardo

With the discovery of the new world by Christopher Columbus in 1492, the race to explore and become wealthy was on. The Spanish had found riches in the lower Americas and were looking for more. Hernando de Soto was the first recorded European to pass through our area, in 1540. He stayed at the juncture of the Etowah and Oostanaula Rivers, on land that is now Coosa Country Club, in an area his scribes referred to as the village of Ulibahali. It is recorded that four of de Soto's men stayed in the area, perhaps the first Europeans and Africans to settle here.

In the principal town on Coosa, near what is now Carter's Quarters in Gordon County, a sick black slave, Robles, was left in the care of the natives, as he was too ill to travel. Another, a Levantine (a European from the Middle East) named Feryada, also decided he was tired of taking orders from de Soto, and, perhaps liking the enchanted land that still attracts visitors today, chose to remain in the area despite pleas from de Soto to rejoin the party. Manzano, "a gentleman of Salamanca," disappeared from de Soto's troop near present-day Rome. It was said that he had become depressed and had started to lag behind until he just disappeared. Only a little farther on, an African slave named Joan Viscaino also escaped the party. This leaves us to wonder if these four ever saw each other again, and whether their progeny became part of the bloodline that later Europeans encountered.

De Soto's group was followed 20 years later by Tristán de Luna. On July 26, 1560, about 150 of de Luna's force arrived at the Head of Coosa on an exploratory expedition. He had been sent by Spain to establish a colony on the Gulf of Mexico. The mission failed. Juan Pardo was sent to the interior of Georgia in 1566. By the time Pardo arrived in this area, the Spanish had worn out their welcome. Word that the Coosa natives were waiting for him and his men prevented him from reaching the Head of Coosa and encouraged his quick retreat back to South Carolina, to the colony he had established there.

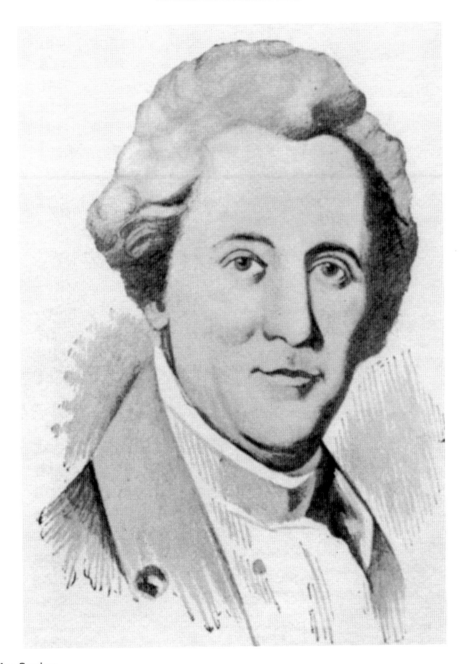

John Sevier

Let us skip ahead to October 17, 1793, to the banks of the Etowah and Coosa Rivers, where a fight to the death took place between 800 militia soldiers under Gen. John Sevier and about 1,000 Cherokees and Creeks led by John Watts. Sevier's forces had pursued these warriors from the Knoxville area after the Indians attacked and destroyed a small family garrison at Catlett's Station. This bloody battle took place near where the South Broad Street bridge crosses today, which at that time was a low-water ford. The fighting was fierce until one of the principal chiefs, King Fisher, was slain. The Indians were routed, and three of Sevier's men and many Indians were killed. Sevier went on to become governor of Tennessee. Some of his descendants live in Rome to this day. (GMB.)

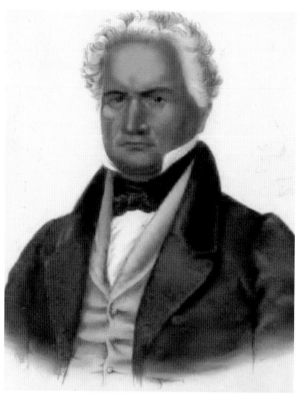

Major Ridge

Ridge, a leader of the Cherokee nation, played a major role in their removal to Indian Territory. On April 1, 1822, as Lucius Bierce was traveling through Georgia, he passed through this area and kept notes in his journal. He described Ridge as a "half breed" and "Chief Orator of the Nation." Bierce continued, "He is a large, and for an Indian portly man, well formed, and handsome address. He wore a blue broad Cloth frock coat and pantaloons, boots, white handkerchief and fur hat, but that on which he seemed to pride himself most was a black silk Cockade with the United States Eagle on it."

Chieftains Museum

Originally a two-room dogtrot cabin built by Ridge, this home is now the Chieftains Museum. Bierce mentions it in his description of Ridge: "Ridge is quite civilized, has a very good hewed log house, brass handles on the door, a small Indian trading house in one part of the building, and lives much in the style of the whites."

John Ross

Recognized by the federal government as the postmaster for Head of Coosa, John Ross lived in a two-story house on a slight rise across the street from the present Fifth Avenue Baptist Church. As the principal chief of the Cherokees, he held out hope that the day of removal would not come and encouraged others of his tribe to resist. Ross and his family left with his people in 1838 on the infamous Trail of Tears to settle in Oklahoma. A former protégé of Major Ridge, Ross was the leader of the National Party that tried to maintain their land in Georgia through negotiations with the federal government. The rift between the Treaty Party and the National Party resulted in a blood feud and killings that went on for a long time.

Quatie Ross

The story of the treatment of the Cherokee people is heartbreaking. They would ask what the rules were for them to remain on their native land and then would do everything in their power to comply, only to be told the rules had changed. Wesley Shropshire, an early Rome settler, was an eyewitness to the eviction of Quatie Ross, the wife of John Ross, and, in a handwritten narrative, he describes her removal from her home at the Head of Coosa:

"The first time I ever saw Col. Z.B. Hargrove and D.R. Mitchell was in January, 1835. Col. Mitchell had said he had bought the Ross lot of land and Col William Bishop of Murray was in Rome with Mitchell and Hargrove to put D.R. Mitchell in possession of the Ross place. Bishop, the dispossession agent, summoned William Smith, Terrel Mayo, Col. J.K. Lumpkin, Robert and John Johnson to go with him over the Oostanaula River to put Ross out and take possession. Mitchell had two Negro men with him and 500lb salted pork. Ross was not at home. Mrs. Ross, a full blooded Indian, refused to give possession. Col. Bishop ordered a bureau thrown out doors. Four men took hold of it. Mrs. Ross then agreed to give Mitchell and his Negroes the upper story of the house and gave an instrument of writing that she would (give) the house up in ten days."

She later met her husband on the road as he was returning from negotiations in Washington. They were evicted from their home, leaving one of their children and John Ross's father, Daniel Ross, buried near their home place. Quatie Ross died of pneumonia on the Trail of Tears in the winter of 1839, after giving up her blanket to a sick child.

CHAPTER TWO

The Road to Rome
Pathfinders and Founders

It was truly a legendary day in the spring of 1834 when two travelers stopped at the spring near the Head of Coosa. The story, as passed down through the generations, says that Daniel Mitchell and Zachariah Hargrove were on their way to the courthouse in Livingston, near present-day Coosa, to transact some legal business. As they were watering their horses at the spring, Philip Hemphill came riding up. Hemphill lived nearby (his house still stands and is now the headmaster's home at Darlington School) and was on his way to Lavendar's store, which stood across from Major Ridge's home (still standing as the Chieftains Museum). As their horses bent down to taste the cool water of the hillside spring, the three men began to talk of the beauty of the area and the bounty of its resources. They spoke of the clean water for drinking, the majestic oaks for building, and the rivers for transportation. After court the next day, the three met again at the Hemphill home and were joined by William Thornton Smith, who owned most of the land they were contemplating developing into a town. Later, they included in their group John Lumpkin, former secretary to his uncle Wilson Lumpkin, the Georgia governor. Together, they decided they would build a town, and, with Lumpkin's political pull, they were able to have the county seat moved to Rome the next year.

Daniel Mitchell

A lawyer and cofounder of Rome, it was Daniel Mitchell who gave Rome its name. It was also he who used a chain to lay out the streets and lots of downtown Rome, which still exist today.

Mitchell Home

This home, built by Daniel Mitchell during Rome's infancy on land formerly owned by John Ross, stood until the 1950s. The site is now home to Dollar General. Today, there is still a home right down the street similar to the original one, which Mitchell built for his daughter. When Rome would flood in its early years, neighbors would find refuge in the high ground of the Mitchell home.

Phillip Walker Hemphill
A planter, cofounder of Rome, and early settler, Hemphill built a fine two-story home on a hill above a clear spring on the Cave Spring Road. He was on his way to Lavendar's store, next to Major Ridge's home and ferry, when he met Mitchell and Hargrove at the spring between the rivers.

Home on the Hill
The Hemphill home, Alhambra, where the original founders stayed and the names from the hat were drawn (see back cover), still stands today and is currently the headmaster's residence at Darlington School.

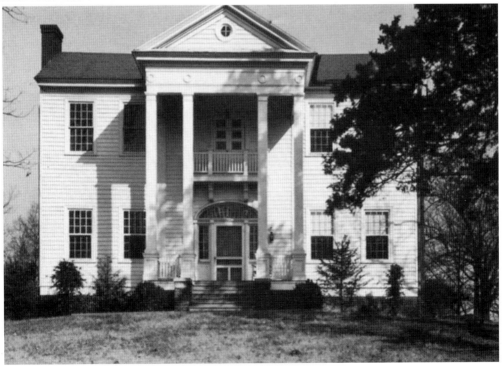

Zachariah Branscomb Hargrove

From Cassville, Hargrove was the other lawyer with Daniel Mitchell when Phillip Hemphill rode up on that fateful day in 1834. Hargrove died in Rome only five years later, at the age of 39, leaving several children who remained in the area.

His son, known as "Little Zach," was a captain in the Civil War and a hero to the locals. He returned to Rome after Sherman started his march to the sea. Rome was beset by scouts and bushwhackers, but that ended when Little Zach returned with his men to drive them away. (GMB.)

WILLIAM THORNTON SMITH
1808 —— 1852
FRONTIERSMAN · FOUNDER · STATESMAN

William Smith

At the time of its founding, William Smith owned most of the land that Rome was built on. He later held office in both houses of the Georgia State Assembly, and he did much to assure the growth of the city of Rome. He was directly responsible for the building of the community's first steamboat, for the organization of the Rome Railroad, and for the coming to Rome of such able citizens as Alfred Shorter and others. There are no known likenesses of Smith, but he has a handsome tombstone in Cave Spring Cemetery.

His daughter Martha Smith married Dr. Robert Battey. She remained in Rome during the Civil War years and wrote of her experiences here during that time.

John Lumpkin

As secretary to his uncle Wilson Lumpkin, the governor of Georgia, John was instrumental in getting the county seat for the newly formed Floyd County moved from Livingston to Rome. He married Mary Jane Crutchfield. He was a lawyer and the first Roman to represent northwest Georgia in the US House of Representatives. He also served as superior court judge of the Rome circuit. (GMB.)

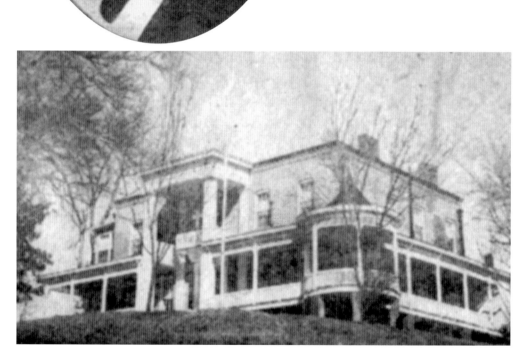

Lumpkin House

This antebellum home stood at the top of Lumpkin Hill on Eighth Avenue. One of the finest homes in Rome for many years, it was used as the first St. Mary's School in the mid-1900s and was later torn down to make room for a hotel and a car dealership.

Not Built in a Day
Community Builder, Business Leaders, and Professionals

The die was cast, the Rubicon crossed, Rome was born! The country was young, and opportunity was everywhere. Settlers were coming in daily to take advantage of the newly forming town and its natural resources. The community was rising, cotton was king, and many migrants from North and South Carolina and east Georgia were looking for new, fertile soil, as their worn dirt had been depleted. Excitement was in the air.

Then, the Civil War came along and knocked Rome on its backside. But, true to its nature, Rome pulled itself up by the bootstraps, and, by the early 1870s, it was booming again. The cotton industry came to Rome, and, with it, the mills. Women fought for the right to vote. Civil War–era restrictions on African Americans were challenged. Equal rights were fought for.

But much of community building happens in small, quiet ways. It happens when someone like Napoleon Fielder encourages neighbors to put aside differences and work together. As he frequently stated, "Working together works." It happens when someone like Elaine Snow breaks the gender barrier in the Rome Police Department and rises through the ranks to become the chief of police. Scattered here among the stories of those who are well known are stories of those who contributed, quietly and without fanfare, to a better community for themselves and their descendants. Also included are some of the places where these legends lived, worked, and were laid to rest.

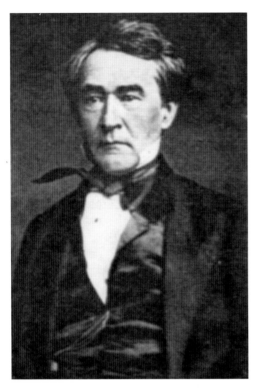

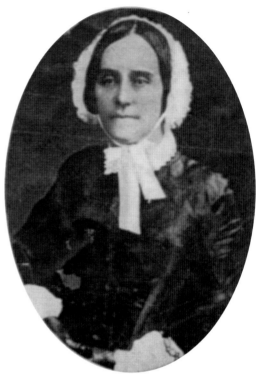

Alfred Shorter and Martha Baldwin Shorter
Arriving in Rome in 1837, Alfred Shorter quickly became the leading cotton merchant and benefactor of Rome. He and his wife, Martha Harper Baldwin, built Thornwood, which still stands today. He went into business with his adopted nephew and heir, D.B. Hamilton. He and his wife financed Shorter College, which originally stood on the hill on Third Avenue and Third Street. Shorter nearly always walked the mile to town from Thornwood with his walking stick under his arm.

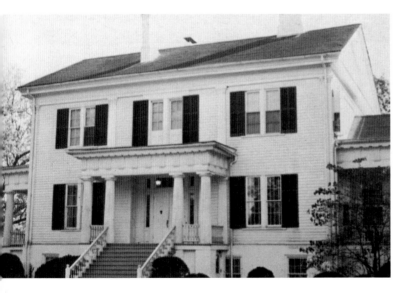

Thornwood
Built in 1847 next to a large spring, this home was occupied twice by Federal troops during the Civil War. It was home to the Hamilton family for years after that. It served as Thornwood School for Girls from 1958 until 1973, when it was merged with the Darlington School. It was home to the Darlington Lower School until it was purchased by Shorter College in 2013.

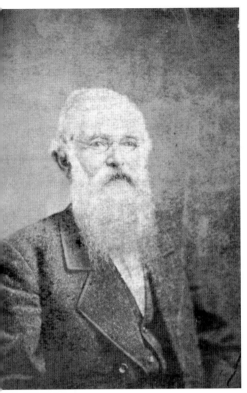

Col. Cunningham M. Pennington
Brought to Rome by Alfred Shorter, this engineer built bridges, a steamboat, and the original Shorter College on East Third Avenue. He was a quartermaster for the Confederate army during the Civil War and continued to work with Alfred Shorter after the war. He owned 400 acres, including where the Coosa Country Club is today, and his descendants remain active in the cultural and political life of Rome. He engineered the layout for Myrtle Hill Cemetery, where he now rests overlooking his beloved farm. (Courtesy of Janet Byington.)

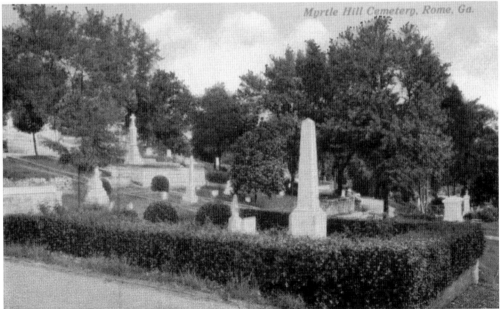

Myrtle Hill Cemetery
Myrtle Hill was designated as the city cemetery in the mid-1850s after the smaller Oak Hill Cemetery began to fill up. During the Civil War, it was a Confederate fort from which an artillery duel was fought during the siege of Rome in May 1864. It is the final resting place for many of our legendary locals.

Dr. Homer Virgil Milton Miller

An early resident of Rome, Miller was a prominent early physician and political force in this area. He defeated former governor Joe E. Brown for the US senate in 1868 but was seated only a few days before his term expired. He was known as an incredible speaker and was called the "Demosthenes of the Mountains" for his oratory skills.

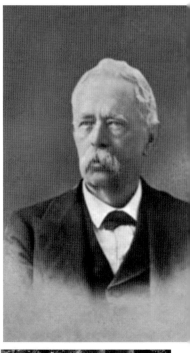

The Miller Monument

Shortly after entering the main road into Myrtle Hill Cemetery, the Miller Monument is on the right. The surrounding small plot contains the resting places of a US senator, a Civil War physician, a Civil War lieutenant colonel, the first major judge of the area, and the national president of the United Daughters of the Confederacy. This tiny square, all the occupants of which are related, could aptly be called the "power spot" of Myrtle Hill. The following pages feature three of these prominent citizens.

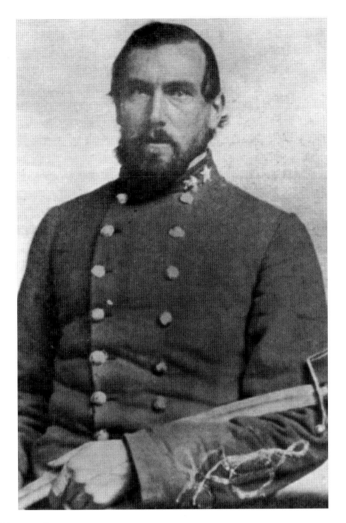

Thomas W. Alexander

Alexander took charge as captain of the Berry Infantry from Rome and rose to the rank of lieutenant colonel. He was married to Sarah Joyce Hooper, daughter of Judge John W. Hooper. Joel Branham, in his book *The Old Courthouse in Rome*, tells us about him so well in the following anecdote:

"Alexander was a large man, six feet high, of fine figure and appearance. He was dignified, deliberate in his movements, and never unduly excited, in or out of court. Though he did not appear to be so, he was very firm in his opinions, sometimes stubborn or obstinate, though not contentious. He never spoke evil of anyone; in every sense of the word he was a gentleman.

"He was Lieutenant-Colonel of the 29th Georgia Infantry in the Civil War; a member of the Georgia legislature in 1859-60; Mayor of Rome in 1876.

"Colonel Alexander was not in the least a nervous man. He was slow and deliberate in his movements, and somewhat indolent. His strength gradually failed as he grew old, until he became bedridden and blind, but his mind never failed. His room was a front one, on the first floor of the Washington Apartments, near the sidewalk on Second Avenue. He longed for company. I visited him occasionally, but, strange to say, the other members of the bar did not. I induced Max Meyerhardt to call on him one time. He told Max how lonely he was. He said, 'I hear footsteps coming, tramp, tramp, tramp, and think maybe he will turn in, but I hear his footsteps die away as he passes by.'"

Alexander is buried in the Miller Monument. (GMB.)

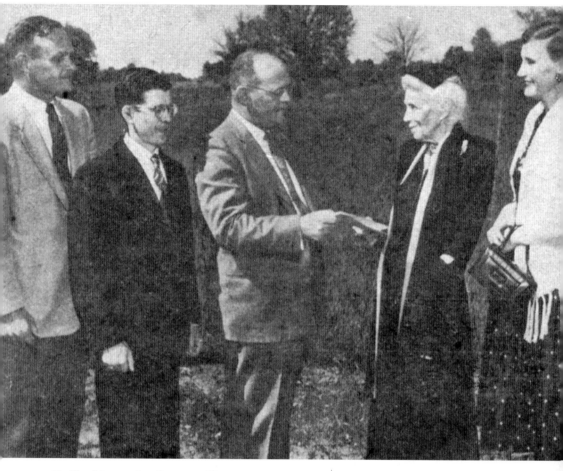

Hallie Alexander Rounsaville

The daughter of Thomas Alexander and Sarah Joyce Hooper, Hallie Alexander Rounsaville's life spanned the time from Sherman's march up through the space age. Born on the day that Atlanta fell to Sherman, she lived almost 100 years. During that time, she was a founding member of the Xavier Chapter of the Daughters of the American Revolution in Rome in 1901, and, from 1901 to 1903, she was president general of the United Daughters of the Confederacy. She was active in numerous civic and patriotic organizations. She attended both Rome Female College and the Cherokee Institute (later called Shorter College). As a personal friend of Ellen Axson and Pres. Woodrow Wilson, she was their guest at Princeton and in the White House. After the death of Mrs. Wilson, on official occasions, she was often requested to lay flowers on Mrs. Wilson's grave. On Armistice Days, she would place wreaths of ivy from Mrs. Wilson's grave onto the grave of the Known Soldier, Charles Graves, buried in Myrtle Hill Cemetery. Mrs. Rounsaville now rests within sight of both graves she was so active in honoring. Here, Rounsaville presents a deed of property to Dr. Tom Moss, an advocate for the blind. To the far left is Vaughn Terrell, a blind attorney, next is Robert Lovell, and on the far right is Laura Hopper. Mrs. Rounsaville is also buried in the Miller Monument. (RN-T.)

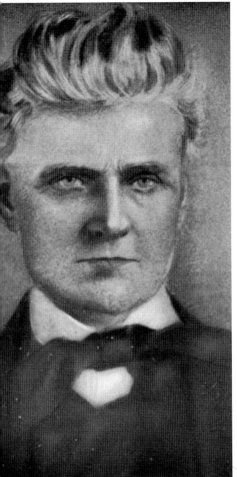

John Word Hooper

Appointed on December 8, 1832, Hooper served until 1835 as the first judge of the Cherokee Judicial Circuit of Georgia. He presided over many cases between the encroaching whites and the resident Cherokees, earning the ire of Gov. Wilson Lumpkin, who tried desperately to remove him from office but was unsuccessful. He had the onerous task of dispensing "justice" regarding the Cherokee at a time when the Cherokee had no rights under Georgia law. Cherokees were barred from testifying in court and could be violated without recourse under state law. Even so, Hooper was reputed to have ruled for the Cherokees on the side of justice on many occasions, which is why Governor Lumpkin tried to have him impeached. Hooper is buried in the Miller Monument. (GMB.)

Anne Culpepper

No reference to Myrtle Hill Cemetery would be complete without mentioning Anne Culpepper. Anne has spent thousands of hours leading adults and schoolchildren over Myrtle Hill, introducing them to the citizens and soldiers who rest under the soil and presenting the history of the hill and the artwork that adorns the graves. (Courtesy of Anne Culpepper.)

Rome City Commission

This photograph from January 1984 shows the emerging diversity of the city commission, with the first female commissioner, Martha Kennedy, and the first and second African American commissioners, Napoleon Fielder and Bonnie Askew.

From left to right are (seated) Buddy Mitchell, Martha Kennedy, and Jerry Dunwoody; (standing) Bonnie Askew, Red Wade, Wallace Hanson, George Pullen, Napoleon Fielder, and Jim Herrington.

George Pullen was chairman of the commission for many years and a familiar presence on Broad Street. He just recently and unexpectedly died of a stroke, leaving the community in shock and with a deep sense of loss. (Courtesy of Joe Smith, city clerk.)

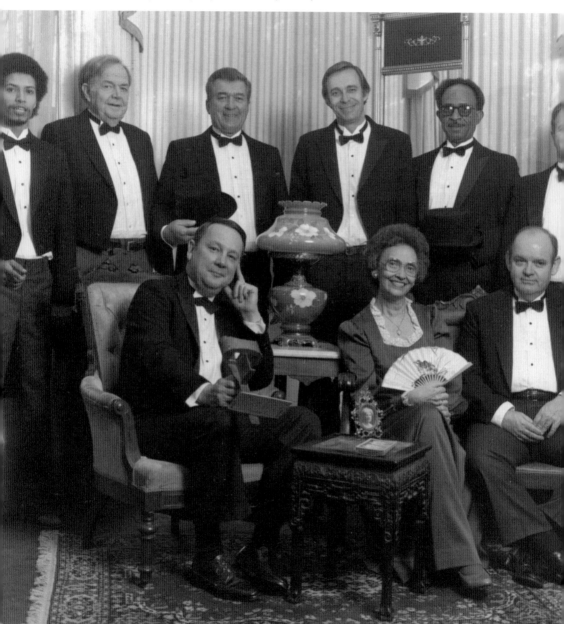

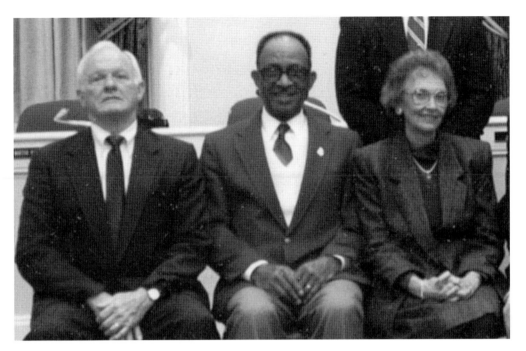

Napoleon Fielder

"I have been the first black on a lot of things. But I don't like recognition, I like results," said Napoleon Fielder. His appointment to the Rome City Commission in 1980 showed the confidence the city leaders of the time had in his ability to lead. He was the first African American to serve on the commission. Fielder's motto was known to be "Working Together Works," and he proved it time and time again. He served until 2002. This 1992 photograph shows Fielder (center) with fellow commissioners Bill Fricks (left) and Martha Kennedy (right). Fielder, a veteran of World War II, also retired from the Army Reserve as a chief warrant officer. (Courtesy of Joe Smith, City Clerk.)

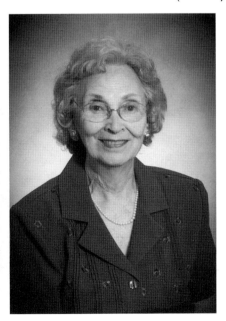

Martha Kennedy

The first woman to serve on the Rome City Commission, Kennedy had earlier served on the Rome City Board of Education. An avid Atlanta Braves fan, she often attended games in Atlanta and is now a loyal Rome Braves follower. (Courtesy of Martha Kennedy.)

Sam S. King

In 1919, when Rome adopted the city manager system, Sam S. King became its first city manager. He ran the city intermittently, depending on administrations, from 1919 until his retirement in 1962, for a total of 38 years. He oversaw the building of the levee in West Rome in 1938, which keeps the Old Fourth Ward from flooding and allows Floyd Medical Center to occupy its present site.

Bruce Hamler

Hamler's big, white Stetson hat was his trademark. He was a larger-than-life figure, highly visible in the municipal political arena of Rome. Hamler was brought to Rome by Sam King in 1939 to upgrade Rome's water system and build a sewage treatment facility. Up to that time, Rome's waste was piped into the rivers. Hamler's job was to build a water treatment facility and divert the more than 70 existing sewage lines into it. Hamler, a large, gregarious personality, loved NASCAR and Allison Kraus's music. His yearly trips to the Indianapolis 500 are legendary among the various guests that he took with him. He succeeded Sam King in 1962 as city manager, spending a total of 39 years working for the city. He made it a point to be the first person to pay his city taxes every year.

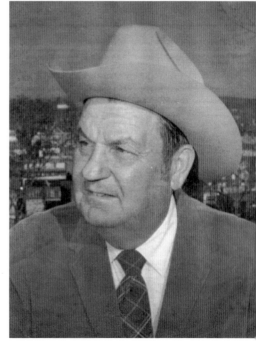

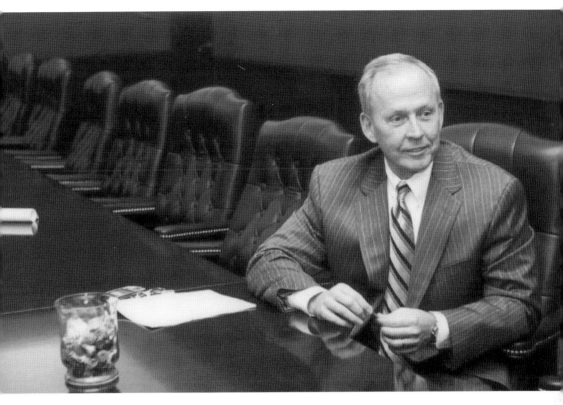

Ronnie Wallace
Rome had a mayor and city council from its inception until 1915, when it converted to a city commission with a commission chairman. In 2002, the commission decided to change the title of chairman to mayor to give more recognition to the position. Ronnie Wallace was chosen in 2002 as the first "new" mayor of Rome, being elected by his fellow commissioners. (RN-T.)

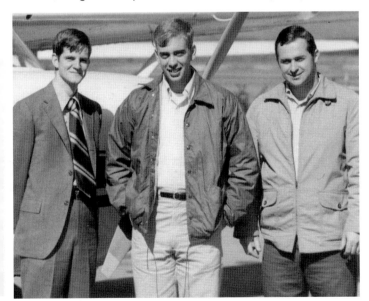

Wright Bagby
A young Wright Bagby (center), Rome's second mayor, and John Bennett (left), longtime city manager, are pictured with Robert Payne, who was associated for many years with Rome Seed and Feed. Wright has unselfishly volunteered on many boards for many years, and he followed Ronnie Wallace to become Rome's second "new" mayor. John Bennett served as Rome's city manager from 1984 until 2014. (Courtesy of Rome Seed and Feed.)

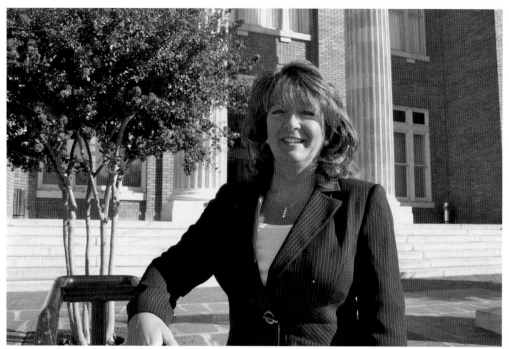

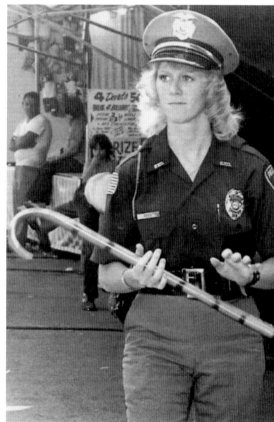

Evie McNiece

An independent businesswoman known for her community service, McNiece was elected to the Rome City Commission in 2007. In 2011, she was elected by her fellow commissioners to become the first female mayor in the history of Rome, and she served in that capacity until 2013. (Courtesy of Evie McNiece.)

Elaine Snow

In 1973, while a student at Jacksonville State University, Elaine Peek did an internship at the Rome Police Department, so she knew what she was getting into when she joined the force the next year as its first full-fledged female police officer. Later on, she married Tommy Snow. When chief of police John Collins announced her hiring, Sgt. Mike Ragland spoke up and said, "I'm not having any female ride with my men." Collins immediately replied, "Ragland, you just solved my problem. She's riding with you!" And she did. She survived and thrived in the environment and paved the way for the female police officers who followed her. She was appointed chief of police in 2010, the first woman to hold that position.

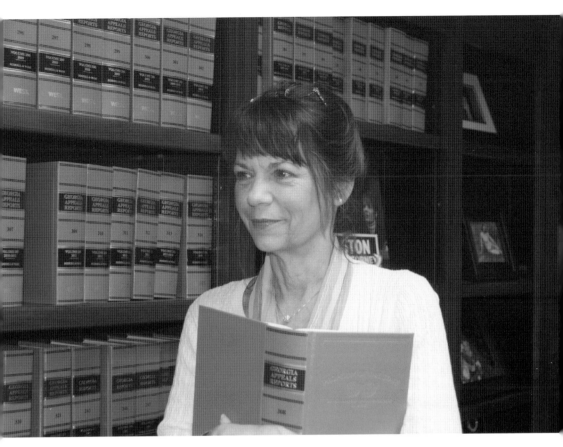

Tami Colston

Leading the way for local women in the field of law, in 1997, Tami Colston became the first elected female district attorney in Georgia who had not first been appointed by a governor, and, in 2001, she became the first female superior court judge for Floyd County. She also argued a case before the US Supreme Court before she had been out of law school long enough to even be sworn in as a member. In addition, Colston knows what it is like to be a victim of crime. While she was the district attorney, she was a victim of identity theft. Someone got possession of all her personal information and ran up over $50,000 worth of bills in her name. The criminal who stole her identity was eventually caught and prosecuted. Shortly after being sentenced, the culprit had the audacity to phone Judge Colston, complaining of the length of the probation she was sentenced to and asking Colston if she could do anything to help reduce the sentence! (Courtesy of Phil Hart, Floyd County Court Administrator.)

Judge Joel Branham

Rome owes one of its best histories of early Rome to Judge Branham, who was a lawyer, judge, and local writer. His descriptions of the compatriots with whom he practiced law are described in *The Old Courthouse in Rome*, which he published in 1922. In it, he describes his fellow lawyers and some of the antics that took place in the courtroom and on the bench during his lifetime. Some of his firsthand descriptions are used in this book. In the 2012 PBS series *Finding Your Roots*, Branham was linked through family tradition and DNA testing as an ancestor of actor Samuel L. Jackson.

The Old Courthouse in Rome

This building stood square in the middle of Fifth Avenue from about 1835 until 1914. It was used as the courthouse for Floyd County until the "new" one was built in 1893. It was then divided into four rooms and became a schoolhouse that was staffed by four teachers and served 200 children until it was abandoned and torn down. The terrace on which it stood was bulldozed so that Fifth Avenue could continue straight through it, and the dirt was hauled to fill in the low spot where the present city hall stands on Broad Street. The only remnant today is part of the terrace wall, which can be seen on the east side of Fifth Avenue.

John W.H. Underwood

When Georgia seceded from the Union in 1861, John Underwood was the Rome representative to the US Congress. He was an astute lawyer and judge after the war. His contemporary Joel Branham describes him thusly:

"He was very able in the trial of cases before the jury, and the most skillful cross-examiner of unwilling witnesses I have ever known. To disconcert him at all, I had to make him angry. This I sometimes did, to his discomfiture, and to my success, in the trial of the case. His fits of anger were brief. It was easy to turn him from them by a few kind words. When in conversation in an office, he sat, hat on, with legs crossed, one foot slightly elevated, the ball or toe of the other on the floor, heel raised, he would shake that leg up and down until you could feel the vibration of the room."

Even Superior Court Judges are sometimes made uncomfortable, as Branham relates: "W.D. Elam had grown old. He seldom had a case in court. He was a clever, good natured man, but for some unknown reason Judge Underwood was prejudiced against him and impatient when he was addressing the court. On one occasion, while he was arguing a question to the court, the Judge took offence at some part of his speech, suddenly stopped him, and said: 'Do you mean any contempt of this court by that remark?' 'Not at all, not at all, your honor! There is no man in Georgia who entertains a higher respect for the Judge of the Superior Court than I do, regardless of the opinion I may entertain of the individual who happens to hold that office.' 'Go on! Go on with the case!' said the Judge. It was the only instance I have ever known in which the Judge was completely discomfited and overthrown." (Courtesy of Cathy Dollar.)

Nim Russell

A joyous occasion marked the 23rd anniversary of Nim Russell being pastor of Thankful Baptist Church. It was a celebration of sharing and laughing and prayer, and everyone went home feeling fulfilled. Within an hour, the community was in disbelief at news that Russell had been killed and his wife, Julia, seriously injured by a drunk driver on their return home to Adairsville. Just 55 years old, Russell constantly preached forgiveness and that God was in control. He was known and loved not only by his church but also by the community at large. It was as if the heart had been ripped out of the church. The people who knew him remember his words of forgiveness for others and his determination to carry on in the wake of tragedy. (RN-T.)

Horace Elmo Nichols
Nichols worked his way up from Floyd County court reporter to chief justice of the Georgia Supreme Court, where he served from 1975 to 1980. He also served as Floyd Superior Court judge in 1948. While chief justice, he continued his residence in Rome, and, for many years, it was a familiar sight to see him driven to his home, at 13 Virginia Circle in South Rome, by the Georgia State Patrol. Known as the "singing judge," Nichols had a degree in piano and voice from Chicago Musical College and sang as a soloist at the Chicago World's Fair in 1933. He was known to give voice on occasion even after his retirement as a judge. (Courtesy of Frank Russell.)

Norman S. Fletcher
Many folks leave Rome and later decide to come back. Fletcher was with Matthews, Maddox, Walton & Smith in Rome from 1958 until 1963, then left for positions in other cities. He served on Georgia's highest court from 1989 until 2005, the last four years of which as chief justice. Because of their regard for Rome's high quality of life, Fletcher and his wife returned in 2003, and he later began working for Brinson, Askew & Berry. (Courtesy of Norman Fletcher.)

Esserman's

Esserman's clothing store was a fixture on Broad Street from 1898 until it closed its doors in 1987, The Esserman family, originally from Riga, Latvia, settled in Rome in 1894. Presley Esserman, pictured to the left, who started the store, was one of several siblings. He was the father of Ben and Hyman Esserman, who worked with him in the store and eventually took it over from him. Ben and Hyman were a team.

Ben kept the books and ran the office, and Hyman was out front meeting and helping customers. Hyman never knew a stranger, and everyone was his friend. He had the ability to make his customers feel like they were the most important people in the world.

Hyman was a veteran of World War I. As a raw recruit, being young and agile, he made the mistake of volunteering for the "track team." His Navy instructor then handed him a mop and bucket and said, "Great, now you are in charge of keeping all the tracks out of the barracks!" Hyman used this to his advantage, however. He learned that base security did not check the bucket, so he would go off post to a nearby brewery, fill up the bucket with beer, smuggle it into the barracks, and sell it by the cup to his fellow trainees. He was always the entrepreneur. He was also an accomplished folk artist and was known for his colorful paintings of Rome.

Esserman's was the first store in Rome to use an honorific "Mr." or "Mrs." to address black Romans. In those days, adult black customers were usually recognized informally by their first names, regardless of their ages. Esserman's was also Rome's first downtown store to employ an African American salesperson to wait on both white and black customers. Hyman (left) and Ben are shown holding up an old photograph of Rome. (Shelley Peller, Rhodeph Shalom Historian.)

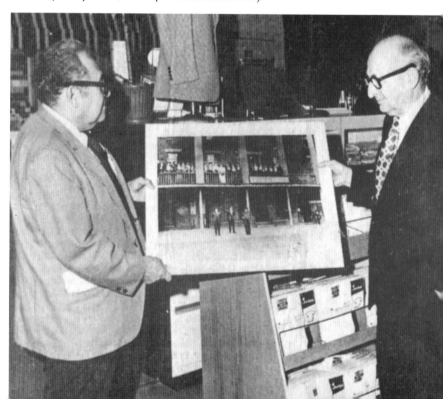

"*In the Heart of Rome Since 1896*"

ROME-GEORGIA

Noble Family

The city clock tower stands today as the symbol of Rome. It would not be here in its present form if not for the Noble family. The Nobles came from Reading, Pennsylvania, in 1855, looking for a desirable place to build an iron factory. During the Civil War, they built cannons for the Confederacy, and, as a result, Rome was targeted for destruction by the Federal army. Sherman destroyed the factory as he left Rome in November 1864 to march through Georgia. One of the sons, James Noble Jr., was mayor of Rome when Rome was placed under military rule in 1865. The Noble family lived on East First Street, adjacent to the Presbyterian church. Their house was torn down to make a parking lot. The Noble family built the clock tower in 1871 as the reservoir for the first city waterworks. (GMB.)

Robert Noble
Robert Noble continues the family tradition of designing and building for Rome in an office at the foot of South Broad Street, separated from the old Noble Foundry only by the Etowah River. Descended from George Noble, his family later returned to this area by way of Cedartown. (Courtesy of Robert Noble.)

Capt. Reuben G. Clark

A Tennessean by birth, Clark came to Rome shortly after the Civil War to start a successful business in dry goods. His brother-in-law was Charles H. Smith, whose pen name was Bill Arp. In the 1892 tax digest, he was listed as the wealthiest man in Floyd County. The spacious 16-room home that he built around 1881 still stands at what is now 305 Clark Drive.

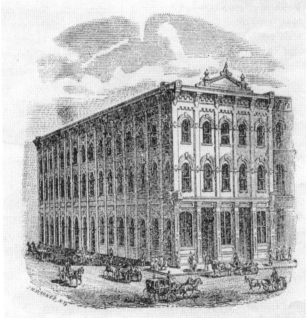

R. G. CLARK & CO.'S BUILDING. (SEE NEXT PAGE.)

R.G. Clark & Co.

Clark's store, which still stands at the corner of Third Avenue and Broad Street, was built about 1873. At one time, it was one of the largest stores in Georgia, with all three floors extending from Broad Street to East First Street. If a building could talk, this one could tell some stories. Later, the second floor was called "Poverty Hall" and had rooms rented out to young up-and-coming bachelors. At one time, the Rome post office was located in the back of the building, and the back iron stairs led to a landing balcony reminiscent of other balconies that once graced Broad Street. Another image of this building in 1890 is shown on page 1.

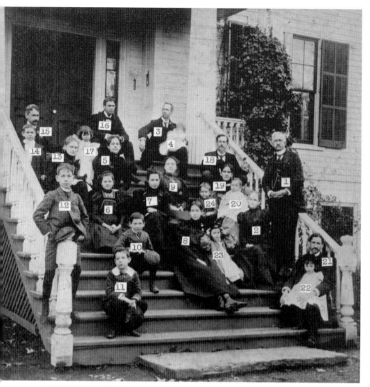

David E. Blount Hamilton
Known as "D.B.," Hamilton was married to Alfred Shorter's niece and became his heir and business partner. He was also a Baptist preacher. Joel Branham wrote of him in his book *The Old Courthouse in Rome*, "He was a lawyer, but he was never actively engaged at the bar. His time was mainly occupied in the care of the business affairs of Alfred Shorter and of his wife's property, and after Colonel Shorter's death with the management of the large estate left his wife by Shorter's will."

Here, D.B. Hamilton (1) is seen with his large family on the steps of Thornwood. The Hamilton Block at the foot of Broad Street was once the office of Alfred Shorter and is one of the oldest on Broad Street.

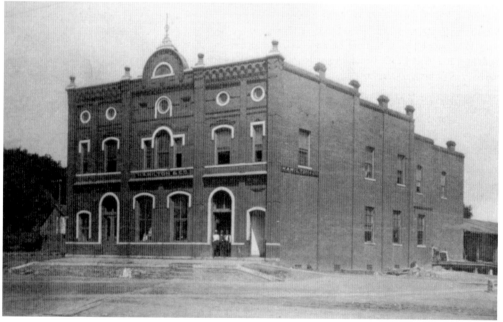

Hamilton Building
This building, built in the 1870s, was formerly home to Alfred Shorter's grocery business Berry & Company. When Shorter died in 1882, the building, shown in 1890, passed to his nephew, D.B. Hamilton, and was later known as the Hamilton Block. The facade was updated in the 1950s.

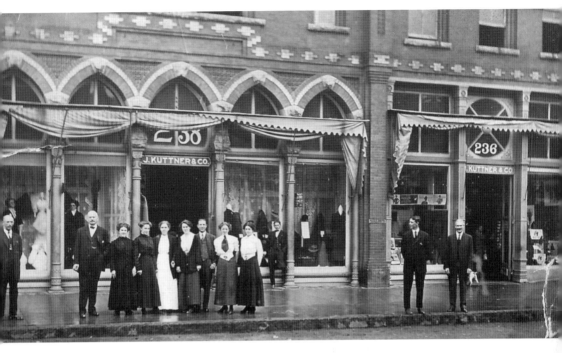

Kuttner's Store

An early trader in Rome, Jacob Kuttner was listed in the Rome city directory of 1880 as a dealer in dry goods and notions. His store and residence were at 123 Broad Street. By 1895, his store had been moved to 238 Broad Street. By 1898, he added clothes to his inventory. In 1904, his store expanded to include both 236 and 238 Broad Street, with his son-in-law Isaac May as his partner.

In 1913, Jacob's sons Samuel N. and Max joined the company. In 1950, Belk Rhodes occupied the buildings at 236 and 238. Today, the building at 238 Broad Street is the home of Mellow Mushroom. This early-1900s photograph shows the Kuttners, May, and some of their employees outside of their store.

Ike May

Born in Alsace, France, Ike May came to America as a young man. He married a daughter of Jacob Kuttner and joined the family business. He served on the city council and oversaw the paving of Rome streets in the early 1900s. He was active in many business enterprises as well as serving as president of the Hebrew congregation. He also had May Realty, which at one time owned a good bit of Broad Street property.

John H. Reynolds

At the age of 31, after four years working with his father's bank in Tennessee, John H. Reynolds was looking to find a promising community that he could grow with. He found it in Rome. In 1877, with his cousin B.I. Hughes, he opened the First National Bank of Rome. Reynolds was a beloved banker and philanthropist in the Rome community. He was recognized as a national leader in banking.

This photograph shows the bank personnel about 1899. They are, from left to right, John Hughes Reynolds, B.I. Hughes, and Hughes Turnley Reynolds.

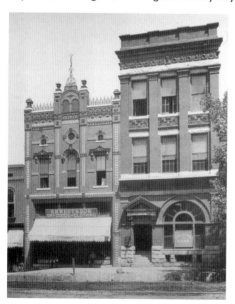

First National Bank

First National Bank is pictured here in 1890 at its second home, at 209 Broad Street, where it moved in 1881. This location is now a parking lot. In 1905, the bank moved two doors down to the Bass & Heard Building, where it remained until 1971. It then moved to Second Avenue and was later bought out by SunTrust Bank. The bank's first home was at 204 Broad Street.

BASS & HEARD

WHOLESALE **WHOLESALE**

Dry Goods, Notions, Shoes, Hats, Etc.....

Five spacious floors, 26,000 sq. feet of floor space. Manufacturers of Pants, Overalls, Duck Coats, etc. Stock always full and complete, prices as low as the lowest. Customers afforded best treatment in every way. Orders earnestly solicited.

WHOLESALE **WHOLESALE**

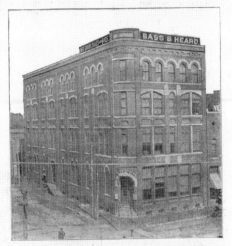

BASS & HEARD

Bass & Heard Building

The four-story Bass & Heard Building, which stands at the northwest corner of Second Avenue and Broad Street, is an impressive sight. It was built around 1892 by Joseph L. Bass and Edwin A. Heard, two successful businessmen from Griffin, Georgia. From 1905 until 1971, the main floor was home to the First National Bank.

Joseph L. Bass

In 1878, Bass came to Rome with his partner E.A. Heard to start a successful dry goods business. While Heard focused on the mercantile business, Bass branched out into a variety of businesses. Bass was vice president of American Bank and Trust and director of the Exchange Banks in Rome. He was also president of Rome Insurance Company and Rome Soil Pipe Company, among many others. He donated his beautiful Maplehurst home and 145 acres of land to Shorter College (now University). The college relocated there from Third Avenue in 1910. Bass was very active in fraternal and civic programs in the community, and left many important and physical legacies that are still with us in Rome today.

Bernard Neal

This Navy veteran is another example of a successful businessman who contributes so much to the Rome Community. Bernard Neal has served on numerous civic boards and has been treasurer for both the Community Concert Association and the YMCA. He has also served as president and treasurer for the Rome Rotary Club, president for the Rome Area Heritage Foundation, and president for the Rome Arts Council. He was in on the ground floor in the establishment of the Rome Area History Museum and has supported it since its beginning. He has been a key figure in the growth and development of tennis for youth and adults. Since 1976, he has served on the board of directors for the Coosa Valley Tennis Association, of which he was president in 1982 and 1983. He also served as treasurer (1984–1986) and president (1986–1988) for the Georgia Tennis Association and on boards at the national level. These are only a few of his accomplishments. He was named in 1993 to the Rome-Floyd Sports Hall of Fame for meritorious service. (RFSHF.)

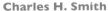

Charles H. Smith

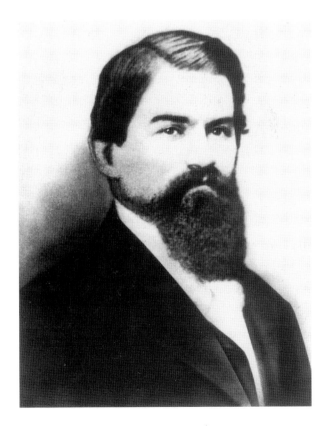

In 1851, Charles Smith came with his father, Ashael Smith, and the rest of his growing family to Rome from Lawrenceville. He was law partners with John W.H. Underwood before the war and with Joel Branham after the war. He served as mayor of Rome in 1867–1868 and in the state legislature. He wrote humorous stories of the war and of Reconstruction under the pen name Bill Arp. Smith was one of the great Southern humorists of the 19th century. He is pictured here with his granddaughter, who later became Mrs. Frank Hammond.

Dr. John Stith Pemberton

Coca-Cola had its roots in Rome. John Pemberton was the son of James Clifford Pemberton, who served on the Rome City Commission during and after the Civil War. John was born in Crawford County, Georgia, and moved to Rome at an early age. He spent his youth and went to school in Rome. His mother was Martha L. Gant and his uncle was Gen. John Clifford Pemberton, the Confederate general who surrendered with several Rome units at Vicksburg. After medical school, he came back to Rome to practice medicine and run a pharmacy for a while before moving to Columbus, Georgia. He later developed the formula for Coca-Cola.

Barron Family and Coca-Cola (BELOW AND OPPOSITE PAGE)

Franklin Smith Barron was born in Carrolton in the early 1870s. He was listed as a grocer at 309 West Fifth Avenue in partnership with Tom Cordle in the 1895 city directory. Family tradition states that he twice went broke in the grocery store business. On January 10, 1901, Barron purchased the Coca-Cola franchise for Rome for $250. It became the sixth franchise in Coca-Cola bottling history. Early on, Barron offered to sell stock in the franchise, but, as the idea of bottling drinks was so new, responses like the one he got from the vice president of Rome Hardware, Robert M. Moss, were common. Moss is said to have stated, "Fizzy drinks, no sir! I put my money in hardware, cold steel I can feel with my hands!" Barron had the last laugh, as he and his descendants became wealthy from the sale of Coca-Cola.

One story in the Barron family has it that Barron was sitting in front of his grocery with several friends one day when they noticed that some liquid was leaking out of one of those newfangled automobiles. One of his friends said, "Look at that gas leaking out of that car." Barron said, "No, that's water." After several minutes of discussion, Barron said, "I'll show you!" He struck a match and tossed it under the car. After the explosion, Barron ended up buying the owner a new car to replace the smoking hulk that was left on Fifth Avenue.

By 1910, the company had become quite successful operating out of 104–106 West Fifth Avenue. Following World War I, Barron's son William Franklin Barron joined the operation. Soon, the company expanded into Carrollton, Cedartown, Cartersville, and, later, Dalton, employing over 200 people and operating over 100 delivery vehicles daily.

By the 1950s, a third generation of Barrons began moving into the family business. They are pictured (opposite page, below) with their father at a district management meeting. Seated from left to right are Mike, Frank, Willie, and Alfred. In his book *How About a Coke*, Frank Jr. recalls the family motto, "Early to bed, early to rise, work like a dog, and advertise!" And advertise they did. The Coca-Cola delivery wagon often did double duty and was used in parades, as shown on Broad Street at Fourth Avenue (opposite page, above). In 1976, construction was begun on a new bottling plant on Highway 27. However, changes in management and methods at the national level led the Barron family to sell their plant for $84 million in 1986. The Barron family is still very active in the civic and economic life of Rome today.

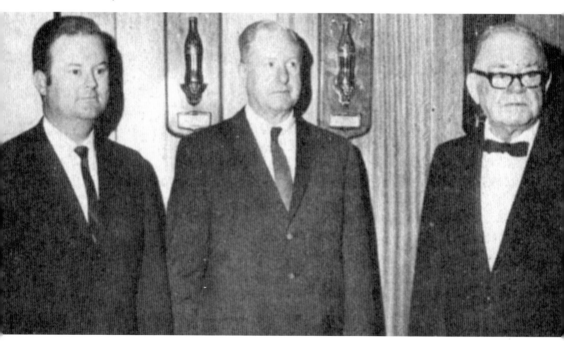

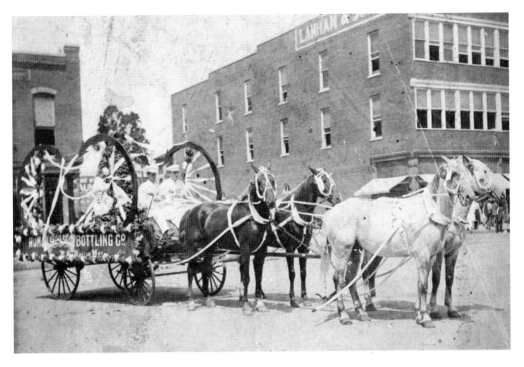

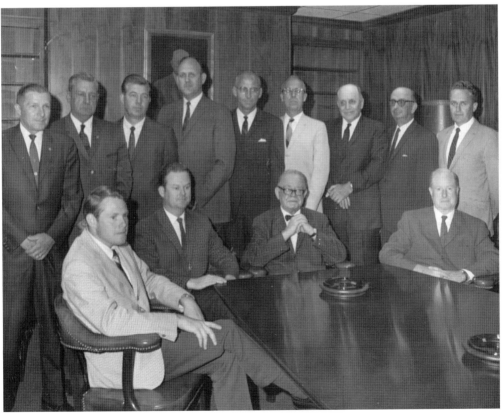

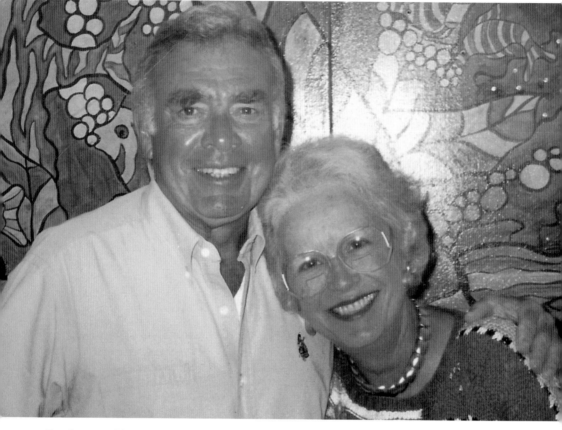

Gardner and Jeannie Wright

The great-great-grandson of Rome cofounder Daniel Mitchell, Gardner Wright tells the story as his grandmother told it to him about the day Daniel Mitchell drew his own choice for the naming of Rome out of a hat. The story goes that after drawing the name, Mitchell slyly looked around the room, grinned mischievously at the others who were looking, and said, "It's Rome!"

A highly successful businessman in the carpet industry, Wright is known for civic and charitable support in the Rome community. The Korean War veteran is a devoted member of the Rotary Club of Rome and has gone over 50 years without ever missing a meeting. His devoted wife, Jeannie, passed away in 2014, and Wright can frequently be seen visiting her grave, just off Broad Street in Myrtle Hill Cemetery. The Rome Area History Museum is one of many community organizations that owe a huge debt of gratitude to Gardner and Jeannie Wright. (Courtesy of Gardner Wright.)

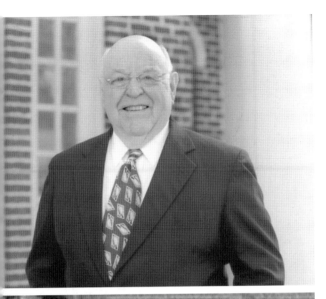

Thomas D. Caldwell III

Bored with school and wanting to do something different, Thomas Caldwell III walked into Rome High School principal J.B. Maddox's office in 1957 to announce he had joined the Navy and was quitting school. He knew the world was bigger than Rome and he wanted to see it. His military experience carried him around the world and back to Rome, where he went into business and raised his family. He opened Rome's first pizzeria, Pizza Roma, in 1963, served as a city councilman and state legislator, and founded his own bank. People who know him feel a calming effect in his presence. His confident, unassuming air is infectious. Bruce Hamler loved to tell this story: Bruce's son Eddie attended Central Primary as a little boy, and Bruce asked him if any of the other boys bothered him. Eddie was quick to respond, "No Dad, I got a guy that does my fighting. He's Tommy Caldwell. He's tough, he's big, and he's mean, and he's my friend." Hamler watched Caldwell grow up and ended up working for him as city manager when Caldwell was elected to the city council, serving four years as its chairman. Caldwell is shown here in 1955 and in 2014. (RN-T.)

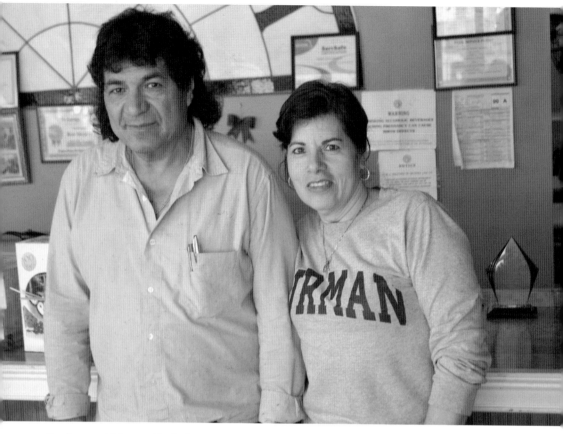

Carlos and Hermelinda Naranjo

Hard work and long hours are normal for the Naranjo/Mata family. Their families have been in the culinary business for a long time. Carlos came from Mexico via Denver and Atlanta, where he was in the restaurant business with Felipe Mata. It was there that Carlos met Felipe's sister Hermelinda, also from Mexico. Married in 1979, Carlos and Hermelinda moved to Rome to open El Zarape Restaurant in 1982. It is a family-owned and operated restaurant to this day. They rented the location, at the corner of Fifth Avenue and Broad Street, from the Essermans, who had a business next door, and they were later able to buy and renovate it into the Broad Street landmark that it is today.

The Naranjos have been US citizens since 1992. Though El Zarape is their main business, they have also invested in other Rome real estate. Like so many of the earlier settlers who came to Rome, they now consider the place where they have worked and raised five children their home.

Alex Mills

In 1947, Alex Mills was named "Most Likely to Succeed" in his Concord, North Carolina, high school graduating class. He has definitely accomplished a great deal since his first job as a newspaper carrier in 1938, at the age of nine, in Concord.

Mills moved to Rome in 1955 to serve as the executive director of the Rome Boys Club, which he did for an impressive 37 years. He was also director of development for three years before retiring in 1996. Since his retirement, he continues to serve youth as a volunteer. Mills has touched the lives of more than 28,000 youngsters in Rome and Floyd County.

Prior to moving to Rome, Mills served as the program director of the Concord Boys Club and was pastor at Tillery Baptist Church. While at the Boys and Girls Club in Rome, Mills pioneered youth athletic programs in Rome and Floyd County and shaped the lives of many through involvement in football, basketball, and wrestling. In 1955, he founded and organized the nationally recognized Rome Boys Club Choir, which was active until 1989 and traveled over 67,000 miles, visiting 23 states and two Canadian provinces. In addition, Mills served on the national board of directors for Boys Clubs of America. (RFSHF.)

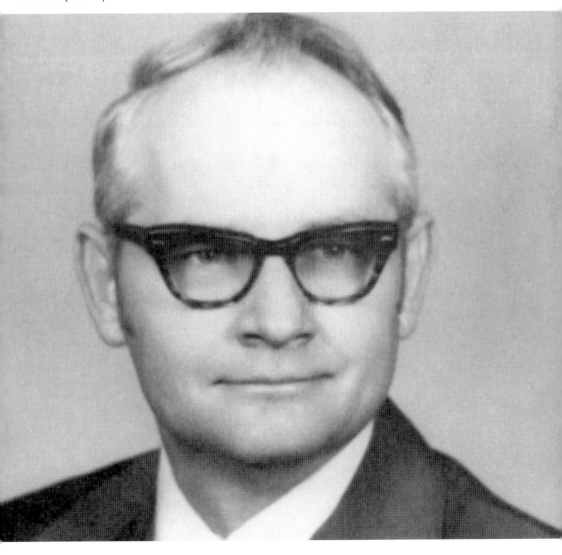

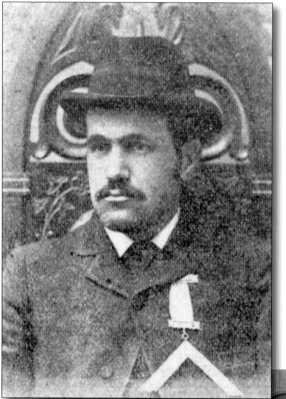

Max Meyerhardt

It is hard to imagine how Max Meyerhardt accomplished so much in one lifetime. The Prussian-born Meyerhardt, who arrived in Rome in 1855, was instrumental in the establishment of Rome's public library and its first public schools. He was a lawyer, judge, poet, and hymn writer, held several offices in city government, and was an active leader in the Jewish community—and this is understating his influence in all of these areas. In addition to that, he was a master mason of the Cherokee Lodge on Broad Street, where he had his office, and he reached the highest degree in Georgia as a grand worshipful master of Georgia Freemasonry. This marker at the Masonic Home for Orphans in Macon is a testament to the good that Max Meyerhardt did in his lifetime.

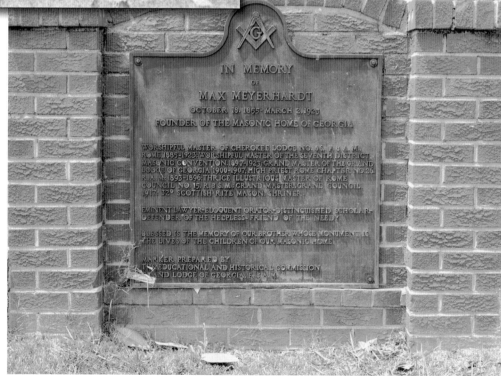

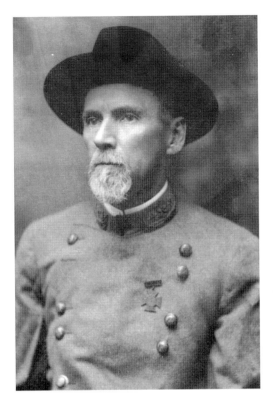

John W. Maddox

Few men have done so much in so little time as John W. Maddox. At the age of 14, he enlisted in the 6th Georgia Calvary, and he served until he was wounded in 1865. He later served as mayor of Summerville, on the county commission of Chattooga County, and as a legislator and senator for Chattooga, followed by a stint as a judge of the Rome Circuit for six years. He then represented Georgia's seventh district in the US Congress for 12 years. His large home stood on Third Avenue, where Heritage Hall now stands. He is shown here in his Confederate jacket, which he wore when he attended reunions. The jacket remains in the possession of his great-granddaughter Nancy Johnson.

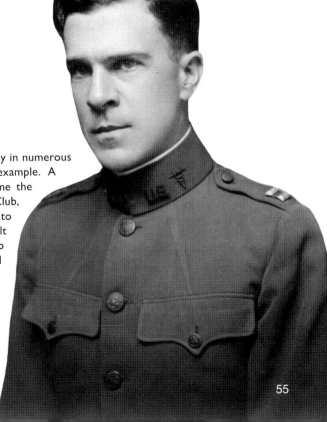

Dr. George B. Smith

Many Romans have served their community in numerous ways, and Dr. George B. Smith is an example. A noted ophthalmologist, in 1914, he became the first president of the Rome Rotary Club, which was one of the first Rotary Clubs to be chartered in a small town. He also built High Acres in 1925, which he later sold to Shorter College and which is now used as the college president's home. He is pictured here in his World War I uniform. Originally from Houston County, he was a trustee of Darlington School for over 40 years, serving 16 years as its chairman. (Courtesy of Nancy Smith.)

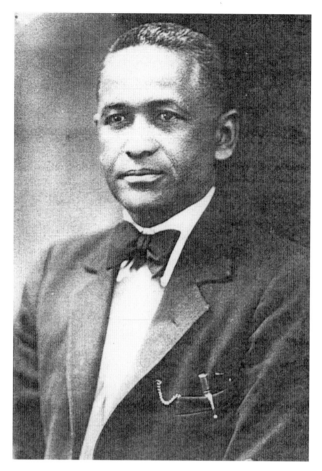

Dr. Jerome Benjamin Bryant

Prior to the 1940s, black physicians were not allowed to practice medicine in local hospitals. They had established private practices, but when it came time for surgery in a hospital, only white doctors could do it. To serve African American patients, Brookhaven was founded by Dr. Robert H. Brooks in 1912. Located at Broad and Ross Streets, the staff of Brookhaven included Dr. Brooks, Dr. J.B. Bryant Sr., Dr. Eugene Weaver, Dr. E.L. Toomer, and Dr. C.I. Cain. White doctors in the area often assisted at the clinic, including Dr. Turner McCall, Drs. William and Robert Harbin, and Dr. A.F. Routledge.

According to Dr. Bryant's daughter Ida, "Although my father treated patients during pregnancy and diagnosed them for various diseases, he was never allowed to enter the hospital to assist or even to observe the completed pregnancies and other procedures. Yet by the same token, the white physicians congratulated him for his accurate diagnosis and treatment prior to surgery. Naturally the white physician reaped the financial benefit of my father's care in prenatal cases. In spite of all of this discrimination, which hurt him deeply, he continued to hold fast to his principles of providing the very best care possible for each patient."

Dr. Bryant was married to the former Emma Cook of Adel, who taught in the Rome city schools for nearly 50 years. Ida followed in the footsteps of her mother and went into education, and her brother Jerome Jr. became a medical doctor and retired from the Army as a colonel.

Samaritan Hospital was founded by Dr. Bryant in 1935. Located at 1106 North Broad Street, at Five Points, its staff consisted of himself, Dr. W.J. Roberson and Dr. J.E. Weaver. Associate physicians were Dr. W.R. Moore of Cartersville and Dr. R.O. Gathings of Cedartown. The hospital provided a clinic for children, where they received examinations and dental care. The hospital closed in 1944.

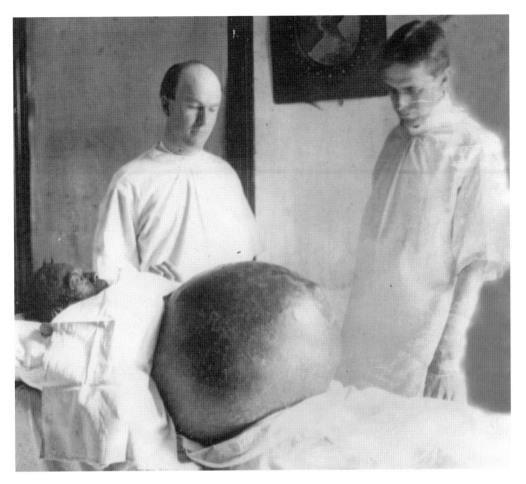

Harbin Family

Harbin Hospital was founded in 1908 by brothers Drs. Robert M. and William P. Harbin. Originally just 12 beds located in a private residence, by 1920, the hospital had moved to a modern building with 75 beds. George Battey, in his *History of Rome*, noted, "It contains every modern improvement and convenience, such as vapor heating and electric light signal systems, silent calls, running hot and cold water in every room, linoleum on cement floors in corridors, noiseless closing doors, and three complete operating rooms. The kitchens are models of cleanliness and the cuisine is in charge of an expert."

In 1917, a 40-bed, four-story building was built next to the original hospital. In 1919, three additional stories were added. Harbin Hospital became the Harbin Clinic in 1948, when it was renovated for physician outpatient offices and air-conditioning was installed. In 1969, the Harbin Clinic moved to a nine-acre site once owned by Berry College. A modern, 40,000-square-foot clinic was constructed at that site, on Martha Berry Boulevard. In 1996, a 40,000-square-foot addition and renovation was completed. One of the more interesting surgeries performed by Drs. William (left) and Robert Harbin (right) occurred in 1906 at a patient's home. They operated on an Alabama man with a large stomach tumor. He had reportedly carried this large tumor in a wheelbarrow for many years prior to this successful operation. The patient lived.

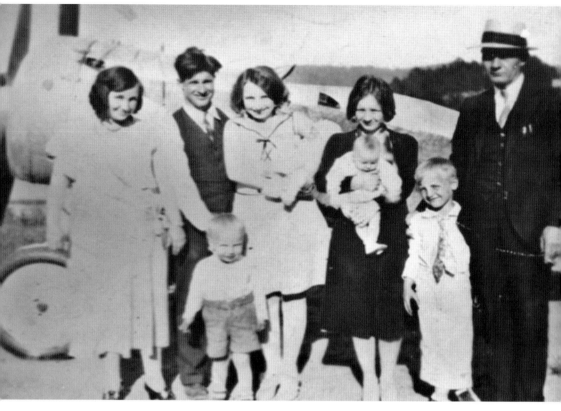

Dr. John L. Garrard

One of the pioneers in the specialty of urology, Dr. John Garrard practiced in Rome for 49 years and helped found the Emergency Hospital in 1919. He was also one of the first aviation enthusiasts in the area, owning Floyd County's first plane, as well as the old Rome Airport. He was known as the "Flying Doctor."

Pictured here are some early Rome flight pioneers. From left to right are Mrs. J.L. Garrard, Robert C. Stroop, Elizabeth G. Stroop, baby Bobbeth Stroop, Merriam G. Hare (holding Elaine Hare), John L. Garrard Jr., and Dr. John L. Garrard. Bobby Garrard is in front.

Dr. William Littell Funkhouser

The first physician in Rome to limit his practice to pediatrics, Dr. Funkhouser came to Rome soon after graduating from the University of Maryland Medical College in 1904. He helped start Curry Hospital in 1916 and helped form a free children's clinic that same year in the brand-new Rome Municipal Building. He later moved to Emory's Egleston Hospital for Children in Atlanta, where he was chair of the pediatric department from 1919 until 1928. He was a pioneer in establishing pediatric medicine as a distinct entity.

McCall Hospital and Dr. Daniel Tucker McCall

McCall Hospital traces its beginning to 1908, when Dr. Daniel McCall made patient beds available over his office and drugstore at the corner of South Broad Street and Forrest Avenue. In 1913, Emergency Hospital operated on the second floor of a building at Broad Street and Fifth Avenue. It moved to 310 South Broad Street in 1916 and was named after Miss Frances Berrien, who contributed $1,000 toward its expansion. Finally, in 1926, Dr. John Turner McCall and others bought the interests of other shareholders and the name was changed to McCall Hospital. It operated at that site until it closed in 1977.

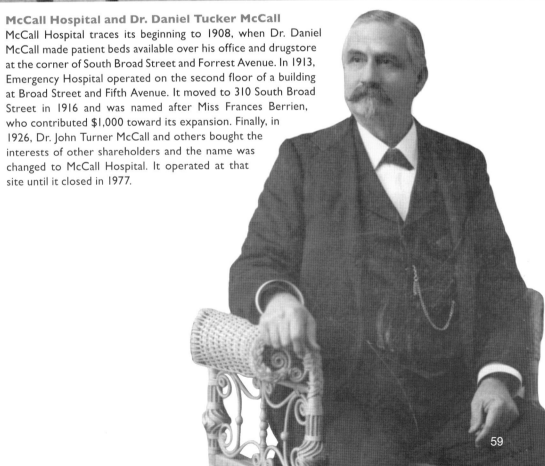

59

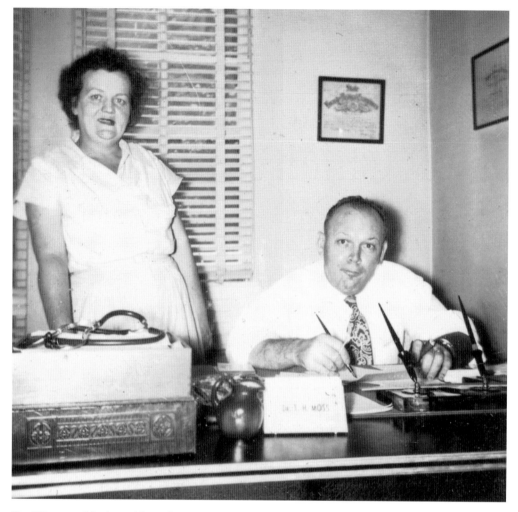

Dr. Thomas Hudson Moss Sr.

Another physician associated with McCall Hospital was Dr. Tom Moss, who practiced medicine in Rome for over 50 years. It is amazing how many Baby Boomers in Rome were eased into this world by his hands. He graduated from the Medical College of Georgia, in Augusta, in 1929 and first practiced in Menlo, Georgia. It was such a rural area that his services were often bartered for things like chickens or moonshine.

One story from his early days was that he was called to the top of Lookout Mountain because a woman was having trouble delivering a baby. He was fresh out of medical school and trying to be as professional as possible, and the old moonshiner husband kept asking him, "Is it time to snuff her?" Moss was a bit surprised but did not want to show his ignorance, so he kept saying, "No, it's not time yet." Finally, with the wife in pain and not knowing what else to do, the hillbilly asked again if it was time, and Moss said, "Yes." The man pulled out some snuff and put it under his wife's nose. She inhaled it, began sneezing, and the baby came out. At least that was the story that Dr. Moss told.

Moss was raised in South Rome, and, upon returning, he opened an office at 409 South Broad Street, built on the site of the house where he was born. He was gifted with a photographic memory and was known for making diagnoses in cases that baffled other doctors. He is seen here seated at his office desk with his sister Mary Jo Dulin, who was also his bookkeeper. (Courtesy of the Moss/McClanahan family.)

CHAPTER FOUR

Teach Your Children Well

Educators and Communicators

When one looks back to their childhood, they invariably remember the teachers that guided and taught them in their early years. They may remember a librarian like Sara Hightower, with her contagious enthusiasm and love of books, and how she managed to get those books to rural areas by using a bookmobile. They may remember Carlos Hamil and Sam Burrell, who guided the school community through the trying times of integration. They may thank teachers like Anna K. Davie or Patsy Laseter for giving them a love of knowledge, or folks like Alex Mills or Predetha Thomas for giving them a home away from home at the Boys and Girls Clubs, which helped raise so many of Rome's youth. It may be coaches like Wallace Wilkinson or Paul Kennedy that come to mind, who taught them a work ethic they appreciate to this day.

Much of the history and culture of Rome would be lost were it not for the teachers and communicators who recorded it and passed it on to future generations. Local journalists George Magruder Battey and Roger Aycock collected and wrote about our history, and Isabel Gammon recorded the details of many societal affairs. These teachers, librarians, historians, and journalists are the guardians of Rome's collective memories, to whom we are indebted now and in the future.

Sara Hightower

A native of Cedartown, Hightower's life was dedicated to children and learning. This petite lady began her career as a Depression-era elementary school teacher and went on to serve as the librarian for Pepperell Schools for 32 years. She spearheaded the use of bookmobiles in a three-county area so that rural adults and children could have access to books. She was noted for her charm and graciousness. She is shown here in the foreground, holding her cane, at the dedication of the Sara Hightower Regional Library, which was named in her honor.

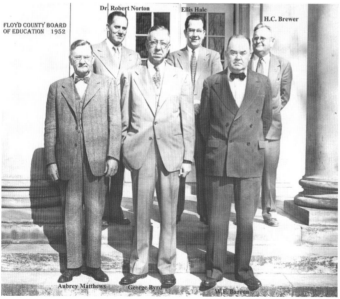

FLOYD COUNTY BOARD OF EDUCATION 1952

Dr. Robert Norton Ellis Hale H.C. Brewer

Aubrey Matthews George Byrd W.E. Barron

Rome Board of Education

In 1887, the first board of trustees for the City of Rome Schools was named by the Rome City Council, and the first public school was built on Clock Tower Hill the following year. The first school superintendent was Benjamin Neely. The board of education continues to work with the city and the schools to keep its students competitive and up to date with the latest educational trends.

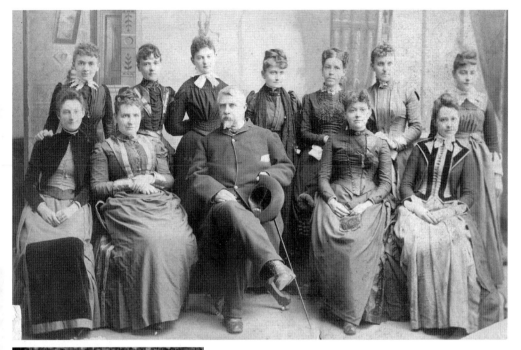

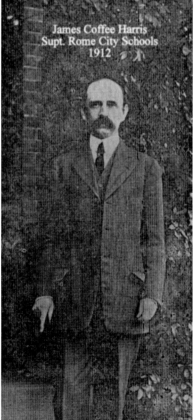

James Coffee Harris
Supt. Rome City Schools
1912

Benjamin Neely

Neely, pictured here with his high school faculty in 1887, was the first superintendent of Rome City Schools. He was hired in 1884 and served until his death in 1892. Neely ran away from home at an early age. He traveled around the world, working on the crew of a merchant clipper ship. By chance, he ran into an acquaintance from America in Dublin, Ireland, who convinced him to come home. He became a Confederate soldier who could infiltrate the Union lines because he "could talk like a Yankee." Upon his unanticipated death, James C. Harris was appointed school superintendent. (Courtesy of Tim Hensley, Floyd County Schools.)

James C. Harris

This gregarious gentleman served as the superintendent of Rome Schools for 24 years after the death of Benjamin Neely, resigning in 1916 to take over as superintendent of Cave Spring School for the Deaf. According to Elmer Grant, everyone called him "the Professor." He knew almost all his students and their parents by name, and he would make daily walks on Broad Street, stopping and talking with people about any subject, much to their delight.

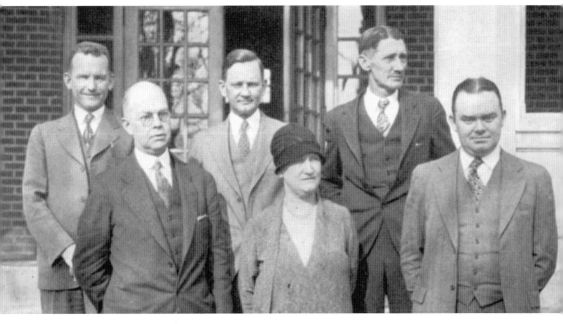

Byard Quigg
One of the most highly respected educators in the history of Rome City Schools was Byard Fowler Quigg, a longtime teacher, principal, and school superintendent from 1920 to 1944. He is shown here with the school board of 1931. From left to right are (first row) Glover McGhee, Mary Taylor Reynolds, and W.F. Barron; (second row) B.F. Quigg, Aubrey Matthews, and George T. Watts. In 1944, Quigg's son, Marine 2nd Lt. Byard Gordon Quigg, was killed in action in Saipan at the age of 24.

Carlos Hamil
Hamil was a longtime educator and the principal of Rome High School and, later, East Rome High School during the precarious years of integration. He was known for his level head and caring personality. He was a teacher chaperone at the time of the Winecoff fire in 1946.

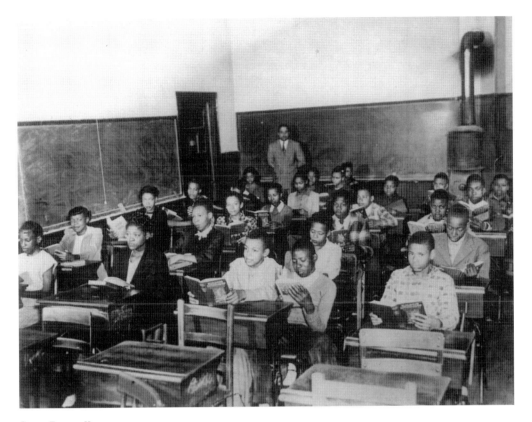

Sam Burrell
A calm influence during the stormy seas of public school integration, Sam Burrell was a teacher and principal at all-black schools Mary T. Banks, Anna K. Davie, and Main High School. When Rome schools were integrated and Main High School closed, he was named principal of West Rome Junior High, where he served for 18 years. He is pictured here with his seventh-grade class at Main High School. (Courtesy of Ernest Daniel.)

Jesse and Patsy Laseter
Jesse and Patsy Laseter grew up in Griffin, where they graduated from public schools. The Laseters moved to Rome in 1968 when Jesse became assistant superintendent of Rome City Schools and Patsy became a teacher for the city schools. Dr. Laseter was then named superintendent of Rome City Schools in 1970, a position he held for 21 years. Mrs. Laseter later became a teacher of gifted students in the five high schools of the Floyd County system. She retired in 1992. After his 1989 retirement from Rome City Schools, Dr. Laseter taught undergraduate and graduate courses in education at Berry College until his second retirement in 2001. Seen here are (sitting in front, from left to right) Jesse and Patsy Laseter; (standing in the center) their daughter Jody Ellison and grandchildren Curt Ellison (left) and Dan Ellison (right). (Courtesy of the Laseter family.)

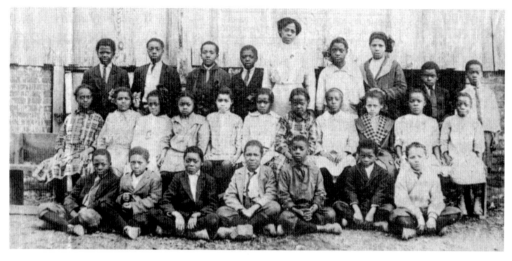

Mary Teresa Banks

This legendary teacher's first school was a one-room school for first- and second-graders on Spring Street, and, in 1912, she moved to the new East Rome Community School, at 1210 Maple Street, when the school added a third grade. She served as both teacher and principal. After her retirement, a school was named after her. This vibrant and energetic lady not only taught and inspired many other African American educators, but she also witnessed much of Rome's early history, including the flood of 1886. She was an avid historian and collector of historical documents until her death in 1975.

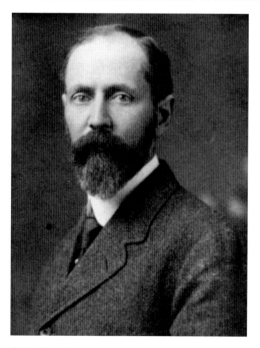
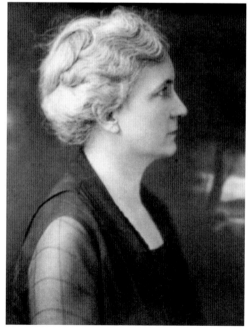

John Paul and Alice Cooper

Some successful business leaders hold on to their money; others share it for the greater good. John Paul Cooper was a successful cotton merchant and businessman who, together with his wife, Alice, helped found Darlington School and build Shorter College at its present location. Their descendants in Rome are still active today in business, education, and the arts.

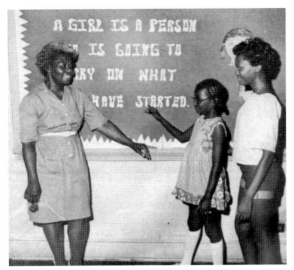

Predetha Thomas
As a teacher at Rebecca Blaylock Nursery, Thomas saw the need for young girls to have a safe refuge after school. In 1959, she started the Girls Club of Rome to provide girls from economically depressed families a chance to learn about the arts, fitness, grooming, and social etiquette.

Hazel Porter
"The most rewarding things in the world are what you can do for somebody else." These words from this consummate community activist sum up the life of Hazel Porter. A kind of Renaissance woman of her day, she was active in almost every facet of public life. For over 37 years, she was associated with Shorter College, where her home was an open door to students, whom she would often guide into being community volunteers. She was involved with the Boys Club Choir, the Rome Little Theatre, the Rome Library, the First Baptist Church, and many others. (RN-T.)

Anna Kennedy Davie Originally from Henderson, Kentucky, Anna Kennedy married Dr. Simeon Davie of Rome. She was known as a compassionate and talented teacher and principal. She lived a rich, full life dedicated to children, her family, and her church. South Rome School, of which she was principal, was renamed in her honor. Her husband graduated from Howard University and was one of the founders of the Rome chapter of the National Association for the Advancement of Colored People (NAACP). He also developed a tonic for heartburn and indigestion and lectured across Georgia as an ordained minister. (RN-T.)

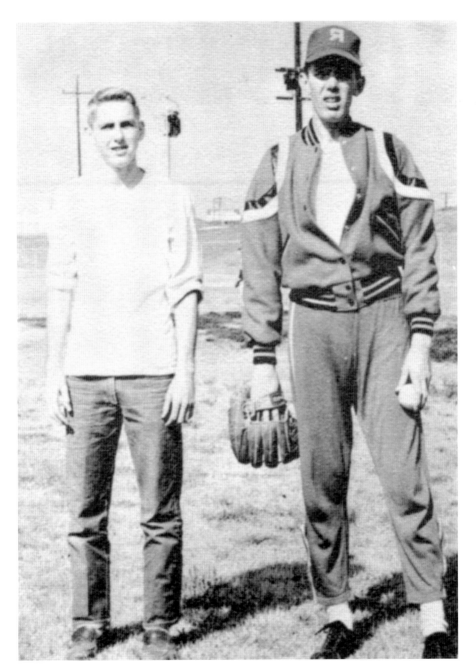

Wallace Wilkinson
Both a coach and an actor, Wallace Wilkinson left a legacy. He was the last head football coach of the Rome High School Hilltoppers in 1958. His legacy includes coaching both Larry Muschamp and Jerry Sharpe, who later became successful and influential as coaches in Rome. In addition to numerous civic activities, Wilkinson was active with the Rome Little Theatre and ended up acting in made-for-TV movies, commercials, and feature films, including *Murder in Coweta County*, *In the Heat of the Night*, and *The Dukes of Hazzard*. This photograph shows Wilkinson (left) with the Rome High School baseball team's manager, Ronnie Mashburn, in 1958. (Courtesy of *The Roman*, 1958.)

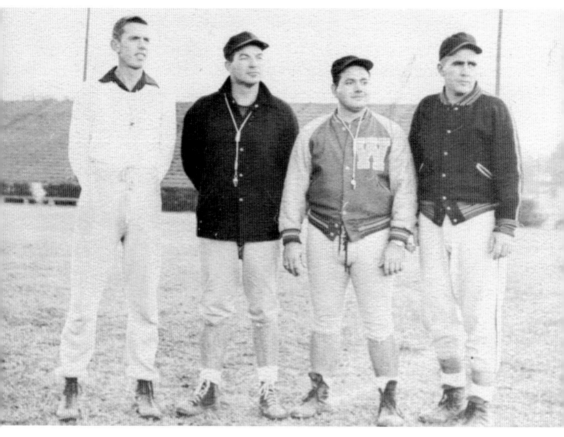

Paul Kennedy

When Rome High School closed in 1958, Wallace Wilkinson went to the new East Rome High, and his assistant Paul Kennedy went to West Rome High to become the first head football coach of each school. A native of Tennesse, Kennedy was named WRGA's Coach of the Year in 1959 and was named the Region Coach of the Year in 1965, 1966, and 1967. In 1965, he coached West Rome to the state AA championship and was named Football Coach of the Year in Georgia by the Atlanta Touchdown Club. Kennedy coached the North Georgia All-Stars in 1966 to a 22-0 win over the South Georgia All-Stars in their annual all-star game.

Kennedy was the co-organizer and a charter member of the Rome Track Club. He also brought high school wrestling to West Rome High School. At the time, Darlington was the only school with a wrestling team. Kennedy is the co-organizer of the popular Northwest Georgia Wrestling Tournament, which began in 1963, and he directed the tournament for nine of its ten years. He headed up the first Special Olympics in Rome in 1971 and stayed active with youth throughout his life. Kennedy is shown here with his fellow coaches at Rome High in 1958. From left to right are Wallace Wilkinson, Paul Kennedy, Owen Blanton, and Jerry Deleski.

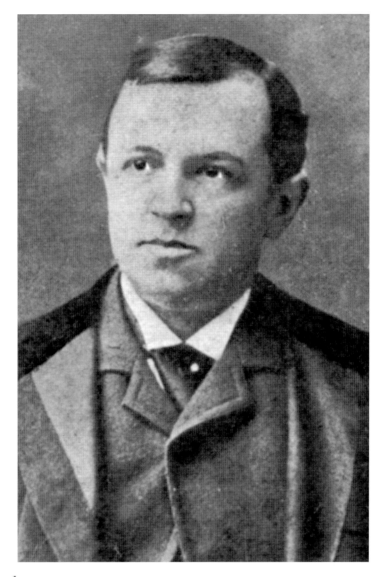

Henry Grady

A fledgling reporter when he first came to Rome, Grady went on to become the best-known advocate of the "New South" after the Civil War. He served as a member of Rainbow Steam Fire Engine Company No. I while he worked as a writer and editor. His brother Will served as his business manager.

J.A. Rounsaville remembers Henry Grady well because of an unusual incident. He recalls, "My brother Wes and I were conducting our warehouse and grocery business when Mr. Grady came by and asked us to give him an advertisement. We told him good-naturedly that his old paper couldn't sell any more goods than we could and that on general principles we didn't believe in advertising. He went away without saying any more about it, and the next day we were treated to a deluge of cats: every small boy in town, it seemed, brought from one to six cats, and when we asked them why they came, they said we had advertised in *The Commercial*. We bought a paper and found a small 'want ad' saying, 'Will pay good cash price for cats. — Rounsaville & Bro.' We sent for Mr. Grady and told him it was his duty to stop the applications. He said he could do that only by inserting a half-page ad. We replied, 'All right, but put in the center of it that we don't want any more cats!'"

Frank Stanton
This noted newspaper columnist came to Rome to write for the *Rome Tribune*. Like Henry Grady, he later went on to Atlanta to write for the *Atlanta Constitution*. He was designated Georgia's first poet laureate by Gov. Clifford Walker in 1925.

Severo Avila
Avila was hired as a features writer straight out of college in Kentucky and is now the features editor for the *Rome News-Tribune*. This native of Belize is known for his humorous, energetic, and to-the-point editorials, as well as love/hate relationships with bacon and the Atlanta Braves. As it was for his predecessors Grady and Stanton when they were in Rome, this is only the beginning of his career. (Courtesy of Severo Avila.)

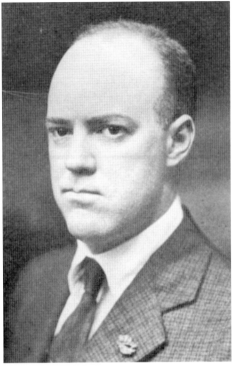

George Magruder Battey Jr.
The grandson of Dr. Robert Battey, George Battey became a news reporter and wrote *History of Rome and Floyd County*, which was published in 1922 and adds greatly to the knowledge we now have about Rome's history.

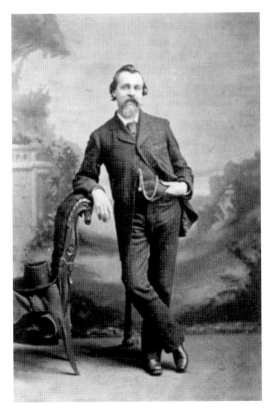

Melville Dwinell
Contrary to Lewis Grizzard's philosophy towards northern transplants ("Delta is ready when you are"), many of Rome's most staunch supporters have been from "up there." Melville Dwinell is a good example. The transplanted Vermonter was an avid secessionist, the editor of the *Rome Weekly Courier* (ancestor of the *Rome News-Tribune*), a lieutenant in the Confederate army, and a Floyd County representative in the Georgia General Assembly.

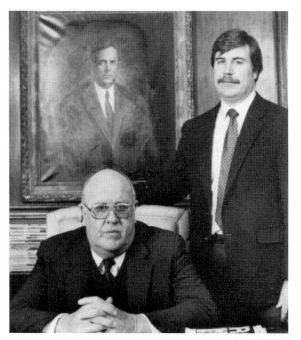

The Mooney Family and the *Rome News-Tribune*
Dating back to the *Rome Weekly Courier* of the 1850s, and throughout a succession of mergers, today's *Rome News-Tribune* is Floyd County's oldest business. The Mooney family has run the family-owned newspaper since 1928 and has seen its transition from handset type to computer and Internet news. Today, the newspaper has the challenge of presenting the printed media to Rome citizens at the same time as it integrates with expanding Web-based media. Beneath this portrait of Burgett Hamilton Mooney Sr. are B.H. Mooney Jr. (left) and B.H. Mooney III.

Naomi Shropshire Bale
The daughter of early settler Wesley Shropshire, Naomi Bale was a frequent writer for the Rome newspapers and wrote of her reminiscences growing up as a young girl when Chattooga County was torn by the Civil War. She was engaged to Maj. Alfred Bale of the 6th Georgia Calvary, who was killed on Christmas Eve in 1863 at Dandridge, Tennessee. She later married his half-brother Capt. James A. Bale, who ran a store at the foot of the Fifth Avenue Bridge, where the parking lot for the Rome courthouse stands today. Their home stood where the historic courthouse was built in 1893.

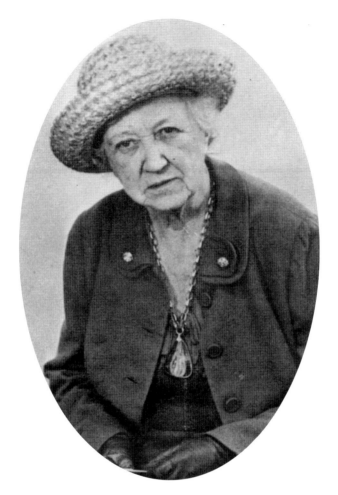

Isabel Gammon

For 36 years, Isabel Gammon was the newspaper society editor for Rome and Floyd County. If there was a wedding or a birth, she was either there or she knew of it, and then she wrote about it. She would knock on the door where a wedding was to be held to see the wedding dress and view the menu. If the bride-to-be wore a yellow linen dress to several parties, it might later be described as "a lovely yellow ensemble with green accessories." She was known as "the Queen of the Rambling Sentence" for her descriptive writing. Her writings now adorn many of the scrapbooks in the care of the Rome Area History Museum.

Her trademark hat and gloves, which she is wearing in this image, accompanied her on her many walks around Rome (she did not own a car), and she was noted for her attention to detail. She would inspect her column before it went to print, and the typesetters could be heard to moan, "Oh Lord, here she comes again!"

But, in spite of that, she had a sense of humor. One Sunday edition stated, "Miss Jones and Mr. Smith exchanged Cows at the Altar." The next day, the staff was heard "mooing" as they passed her desk. She once wrote, "Miss Smith wore 'ask Miss Gammon'" on her copy but forgot to change it before submitting it. That is exactly how it appeared in the next day's paper.

Gammon was known for her kindness and generosity in and around Rome. She continued to contribute to the *Rome News-Tribune* up until her death in 1971. She was known to have reported on the births, first birthday parties, first dances, graduations, marriages, and house parties of many of Rome's citizens. (RN-T.)

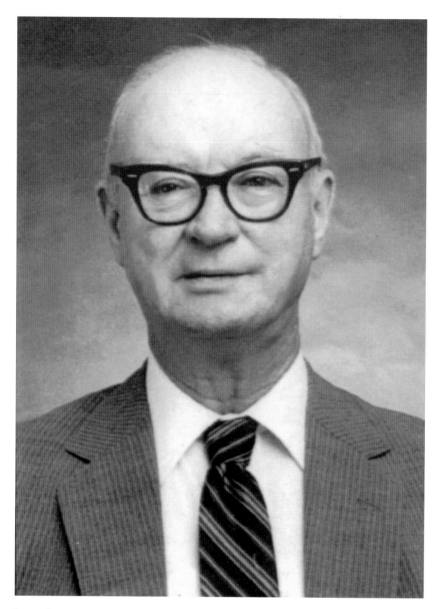

Roger Aycock

There was a time in Rome when, if one needed a violin, viola, cello, or upright bass repaired, Roger Aycock was the man to see. This shy, humble man was an enigma to many of those who knew him. For many years, he delivered mail on Broad Street. As he walked, his mind would wander. He would think of odd stories and go home to write them down as science fiction. He was published in that genre and widely read under the pen name Roger Dee. His work appears independently and in books and magazines alongside such notables as Robert Heinlein and Isaac Asimov.

Aycock played violin for years with the Rome Symphony Orchestra and even repaired most of their instruments. Later in life, he began playing old-time and Irish fiddle music with the Georgia Mountain Music Club. For years, he wrote a column for the *Rome News-Tribune* on local history. Perhaps his most lasting legacy was his book *All Roads to Rome*, published in 1981. This book is written in an organized and literary style to be enjoyed by future generations.

CHAPTER FIVE

The Roman Circus
Entertainers, Artists, and Athletes

Rome is an arts town. The Rome Opera House opened in the 1880s and featured national and local performers. More recently, many Romans have been involved with the very active Rome Little Theatre, and some, like Wallace Wilkinson, have appeared on national television. The Rome Area Council for the Arts promotes contemporary artists like Susan Harvey, who produces art that resists definition. Ellen Axson Wilson, who is primarily known as the former First Lady of the United States as the wife of Pres. Woodrow Wilson, was a first-class painter who sacrificed that profession to support her husband's academic and political career.

Rome was long known for its textile manufacturing, and Rome resident Frankie Welch took it to the next level by designing dresses and scarves for celebrities and presidents' wives. Locals like Edith Lester Harbin and Helen Dean Rhodes shared their love for music by inspiring and teaching children of all ages. John Carruth put Rome in the spotlight by taking the music of the internationally known Eighth Regimental Band on tour across the continent.

More contemporary musicians like Stranger Malone, who played on some of the earliest recordings made, and Paul Goddard, a member of the Atlanta Rhythm Section, got their start in Rome.

The Rome-Floyd Sports Hall of Fame is dedicated to recognizing and honoring the gifted athletes that come from this area, several of whom are noted in this book. Larry Kinnebrew and Ray Donaldson were both local players who excelled at the national level in football. The textile leagues brought entertainment and pride to both owners and workers, as the millworkers could relieve an otherwise dreary existence by cheering on their teams on weekends. In the following pages, readers will meet some of those Romans who have put Rome on the map and "seen their names in lights."

Ellen Axson Wilson

Perhaps the most famous legendary local to come out of Rome is Ellen Axson Wilson. The daughter of a Presbyterian minister, she met and was courted by Woodrow Wilson in Rome when Wilson would visit his aunt and uncle. Ellen attended the Rome Female College, which stood on Lumpkin Hill on Eighth Avenue, and was an accomplished artist at an early age. She was planning to be part of a large homecoming celebration in October 1914, when she was First Lady, but, sadly, she died unexpectedly of a kidney disease. Instead, she had her homecoming in August 1914, when she was laid to rest beside her mother and father in Myrtle Hill Cemetery. Her funeral and burial are legendary and marked a time when the eyes of the world were on our city. (GMB.)

Frankie Barnett Welch

This textile designer, manufacturer, and fashion coordinator to stars and politicians was born in Rome and graduated from Rome High School in 1941. Welch produced scarves and ties for American presidents, including Lyndon Johnson, Richard Nixon, Gerald Ford, and Jimmy Carter. She also designed items for the first ladies. Betty Ford (right), shown here with Welch, wore the first scarf that Welch designed, based on the Cherokee alphabet. In 1976, Mrs. Ford donated a gown designed by Frankie Welch to the Smithsonian First Ladies' Collection for permanent exhibit. Frankie Welch has completed over 3,000 commissioned designs. She also owned a dress shop for many years in Alexandria, Virginia. Elizabeth Taylor and Barbara Sinatra are listed among her many clients. (Courtesy of Frankie Welch.)

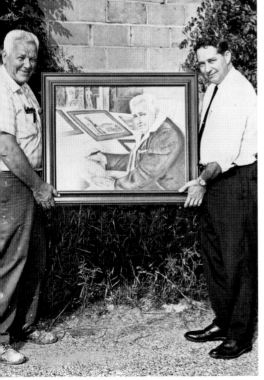

Robert Redden

Redden did not seriously take up art as a profession until his 50th year. Previously, he had worked as a baker and sign painter for Coca-Cola. Without formal training, he soon began winning awards across the state of Georgia for his original pen-and-ink drawings. In 1969, he was a prize winner at the Southern Contemporary Art Show, and he had two one-man shows in Nashville, in 1970 and 1972. He is best known for his drawings of scenes in Rome and Floyd County. He is shown here (on the left) accepting a portrait from Ralph Sargent in August 1968. (Courtesy of Milton Photography.)

Edith Lester Harbin

Harbin began a long musical legacy in Rome. The founder of the Rome Music Lovers Club (1904) and the Junior Music Club (1917), she also created the first Junior Orchestra in Georgia in 1919, with 28 members. In 1921, Harbin's students combined with Paul Nixon's Orchestral Band of Lindale to form the Rome Symphony Orchestra (RSO). According to an editorial in *The Baltimore Sun* in June 1923, "It was the first and only symphony orchestra in the South." Shorter College faculty members and violin students of Arthur Talmadge also joined the orchestra. The RSO performed its inaugural concert under Nixon's direction on May 11, 1922, with a program of Strauss waltzes, the overture to Weber's *Der Freischutz*, and other selections. The soloists were Mrs. Taul White and M.G. McWilliams. The concert took place during Rome's first observance of music week.

Paul Nixon

"Mr. Nixon is the center of Rome's musical world," was how one Rome writer summed him up in 1926. Much beloved by the people of Rome, Nixon directed the Lindale band and the Rome Symphony Orchestra. He led an army band in France during World War I and returned to Rome, where he continued to lead, inspire, and write music.

Paul Nixon continued to conduct the Rome Symphony Orchestra until it was temporarily disbanded in the 1930s. The Rome Chamber of Commerce presented Nixon with a citizenship award in 1932 for his contributions to the high caliber of music in Rome.

John Carruth

Originally from Gadsden, Alabama, Carruth started out playing music there along with Steve Young, a nationally known songwriter who penned "Seven Bridges Road," made famous by The Eagles. Carruth later conducted the Rome Symphony Orchestra, from 1976 to 1995. This stellar musician, who was also one of the founders of the Rome Area History Museum, went on to form the nationally known Eighth Regiment Band, which has toured all over the United States and Canada. Carruth (right) is pictured with longtime Rome Symphony Orchestra concertmaster Louise Hoge.

Helen Dean Rhodes

Music was her life, and Helen Rhodes's legacy to Rome was as conductor for the Rome Symphony Orchestra for almost three decades, beginning in the late 1940s.

Her background was vast. The Rome native, born in 1896, studied at the Atlanta Conservatory, Brenau College, Shorter College, and Columbia University. She participated in solo and chamber music circles and in New York City radio musical programs for the first half of her career, and managed the Orchestra Classique, one of the two all-female orchestras in the United States at the time.

At age 50, Rhodes returned to Rome to take the reins as conductor of the Rome Symphony Orchestra. The first concert she conducted was in January 1948 at Rome Girls High School, now known as Heritage Hall. She conducted the local orchestra through its 1975 season.

But her musical reach extended even further. She was also the director of music at First Presbyterian Church for 25 years. For many years, she was known to have traveled by Greyhound bus to Summerville, where she taught piano and violin. She also worked with musical programs in Rome and Floyd County schools. She did a stint as director of the orchestra at Rome's Rivoli Theater for silent films.

Through her music, Rhodes touched the lives of thousands in Rome and beyond. She died on September 14, 1976, just shy of her 80th birthday, having only recently relinquished her conductor's baton due to illness. Rhodes (left) is pictured here in 1924 holding her violin. Margaret Bryson is to her right, and James W. Bryson is seated.

Stranger Malone

At the age of 15, when Kasper Malone was "accepting rides" in Florida on his way back to Kentucky in 1924, the driver stopped in Armuchee to get gas. A band of musicians was tuning up in the store, so Malone got his baritone sax out of the car and said, "I think I'll stay here for a while." One of the musicians asked, "Who is that there stranger with the big horn?" From then on, he was known as "Stranger" Malone.

This was a time when the record industry was just beginning, and Malone was soon in an Atlanta recording studio on Prior Street making records with musicians like Riley Puckett, Clayton McMichen, and Gid Tanner. After several years in the area, Malone left to continue his music with other greats, touring the United States with Jack Teagarten's All Star Band and others.

He moved to Germany, lived there for many years, and later came back to Rome, where he spent the last 20 years of his life. Recognized for his musical ability and historical connection to music of an earlier era, Malone continued to play locally and all over the Southeast. He continued to record with local bands such as The Little Country Giants and The Groundhawgs, and in Atlanta with Mick Kinney and Elise Witt. In 2000, he was presented with the Rome Area Council for the Arts' first Lifetime Achievement Award, and, in 2003, he was awarded the Guinness World Record for Longest Working Career as a Recording Artist. Malone died on Memorial Day in 2005 with the book *Life is Worth Living* in his hand, just three days after playing an evening gig at the Harvest Moon Restaurant on Broad Street. He is pictured here playing at Rome's Chiaha Festival in 2003. (Photograph by Nancy Smith.)

Paul Goddard
East Rome High School graduate Paul Goddard grew up in Rome and attended school at Central Primary School. He moved to Atlanta to play music and was the original bass player for the Atlanta Rhythm Section. He played his last concert with them in Rome on March 8, 2014, and had a reunion with his old classmates shortly after that show. He died unexpectedly seven weeks later. Goddard (right) is pictured in his high school yearbook in 1963 with classmate Pat Ford. He was voted "most talented" in his graduating class.

Susan Harvey
It would be difficult to find anyone in Rome as creative as Susan Harvey. She is the originator of the annual Clock Tower Egg Stand, which has occurred on the first day of spring every year since 1984. She is a sculptor, author, and innovator, among other things. Her artistic creativity and ability have been honored nationwide. Most Romans are unaware of the high standing that Susan Harvey has in the state and national art community. (Photograph by Derek Bell.)

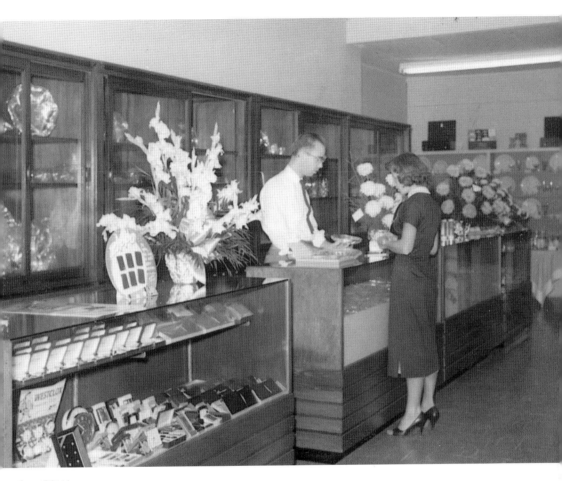

Joe Gittings

There have been many jewelers on Broad Street, and the much beloved Joe Gittings stands out among them. He is both an artist and a businessman. Gittings first came to Rome in 1953 from Roanoke, Alabama. After a short stint with Macon Brock on Broad Street, he worked for five and a half years with Dabney Hardy at Hardy Jewelry Company. In 1958, in partnership with William Ford and Bill Kane, Ford, Gittings & Kane Jewelers, at 312 Broad Street, was born.

Gittings's father was a disabled veteran of World War I who was trained by the Veterans Administration as a watchmaker and jeweler. The Gittings children grew up working in the family jewelry store in Roanoke. Gittings remembers when people would come from all over northwest Georgia and northeast Alabama to shop in downtown Rome on Saturdays. He has lived long enough to witness the migration of stores and shoppers to the mall, and now sees them coming back to a revitalized downtown. He is leaving a legacy for his daughters, who continue to operate the store along with their partner, Jan Ferguson. Gittings is shown here helping a customer in his store in the 1950s. (Courtesy of Ford, Gittings & Kane.)

Marty Lundy, "Arn Anderson"

Growing up in South Rome, Marty Lundy was prone to get into fights with bikers and bullies. He spent a lot of time in the basement of the Moss home, on Lookout Circle, working out with Bobby Moss. Bobby was skinny and trying to build muscle; Marty was heavy and trying to lose fat. They were both successful. Bobby went on to open Bob's Body Shop for athletic training, and Marty went on to become a professional wrestler known as "Arn Anderson." He is a member of the World Wrestling Entertainment (WWE) Hall of Fame for professional wrestling and has had two action figures made of him in his wrestling attire. These pictures show Lundy (right) with his childhood friend Bob Moss, and as an action figure in his role as Arn Anderson, professional wrestler. (Courtesy of Bob Moss.)

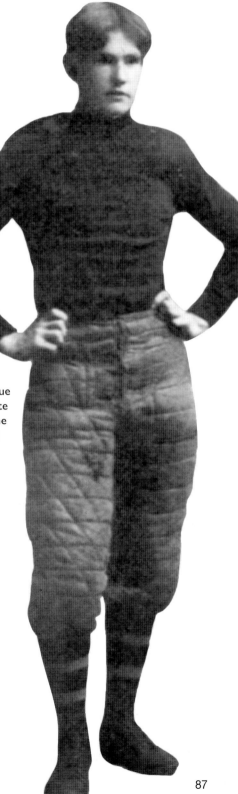

Von Gammon

On October 30, 1897, Rome lost 18-year-old Von Gammon to a football injury, and Georgia almost lost football as a sport. The game was in Atlanta's Brisbane Park between the University of Virginia and the University of Georgia. Gammon was playing defense, and, after a brutal pileup, when the players separated, Gammon lay unconscious. He was carried to a nearby hospital and died 11 hours later.

Football was a fairly new game and already a bit controversial. After the death of such a popular and promising young man, editorials and letters began to be written against football. A bill was passed outlawing football in the state, and it was only because of a plea from Gammon's mother to Georgia governor William Atkinson that the law was vetoed. She stated that her son would not want his death to be used to abolish a sport he loved.

The Gammon home was located at 420 East Third Avenue and was a favorite gathering place for the youth of the late 1800s. There is a marker dedicated to his memory on the northwest corner of Broad Street and Fifth Avenue. (GMB.)

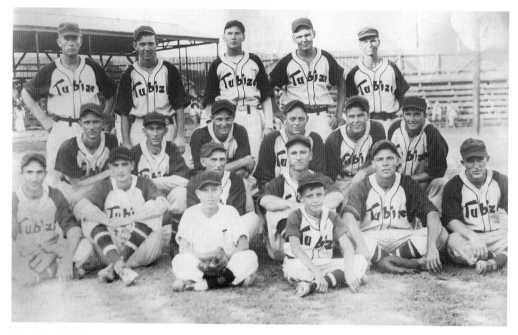

The Textile Leagues

Baseball has been a favorite sport in Rome since the Civil War, but it may have reached its heyday in the years just before World War II. The textile industry was booming, and each of the mills hosted its own team. Weekend baseball games were huge family events and provided a recreational and spectator sport for many of the textile mill families. This photograph shows members of the 1938 Tubize championship team. Harry Boss is standing fourth from the left. To his right is Cliff McClanahan. On the far right of the second row is Leon "Cubbie" Culberson, who went on to play with the Boston Red Sox in the 1946 World Series.

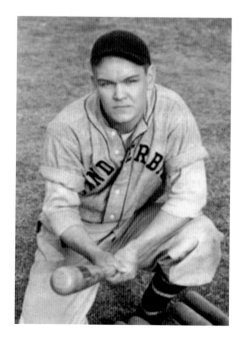

Harry Boss

Harry Boss, a graduate of Darlington School, was an All-American baseball outfielder at Vanderbilt University in 1939. He served as a master sergeant in World War II and had the experience of being personally cussed and chewed out at length by Gen. George Patton when he failed to camouflage his convoy while his men went for lunch in a pub in England. He was a member of a group of old-timers who met at the Partridge Restaurant and, later, at Chick-fil-A to reminisce about the textile leagues. Incidentally, Boss was responsible for bringing the editor of this book's father, Cliff McClanahan, to Rome to play in the textile league in 1938. McClanahan met his future wife, local Billie Fleming, during that time, so Boss made an indirect impact on the publication of this book! (RFSHF.)

Larry Kinnebrew

Lettering in football, track and field, and wrestling and becoming a state champion in discus, shot put, and the 100-yard dash helped Larry Kinnebrew earn the title of East Rome High's Top Athlete. In track and field, while standing 6'2" and 255 pounds, Larry ran the 100-yard dash in 9.5 seconds, becoming the largest Georgia athlete to win the state 100-yard dash title. Larry won the Class AA 100-yard dash in 1977, beat Herschel Walker in the 100-yard dash in 1978, and won state titles in shot put and discus as well. His football career, however, has earned him recognition as being one of the top linemen and defensive players in the NFL.

In 1983 he signed with the Cincinnati Bengals, leading the team in rushing twice during his five seasons and scoring 36 career touchdowns. He played from 1989-1991 with the Buffalo Bills, averaging 4.5 yards per carry with 44 touchdowns. As a receiver, he gained 660 yards on 70 catches for an average yardage of 9.4 with 3 touchdowns. Larry retired from the NFL in 1993 and returned to Rome in 1994 where he coached for the Youth Football program through the Parks and Recreation Authority and the Boys and Girls Club. He also served as a volunteer for the national Youth Sports Program at Floyd College and Rome High School. (RFSHF.)

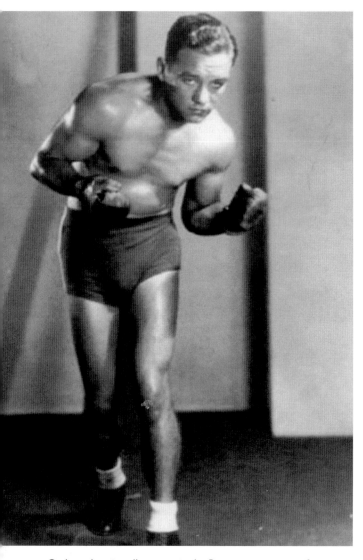

Carl Knowles

On the evening of January 17, 1964, Jane McCollum was riding down Shorter Avenue in a car with her date when she saw a familiar figure walking and weaving down the street. It was her uncle, Carl Knowles, a once nationally ranked boxer, who had succumbed to the bitter call of alcohol. Embarrassed and disgusted, she told her date to keep driving. But after a few seconds, her conscience got the better of her and she and her date turned around, stopped, and picked her uncle up. They pulled into the Krystal on Shorter Avenue to get him some food and coffee to sober him up. She said, "Uncle Carl, you need to quit drinking. It is going to kill you." He got a funny look on his face, and said, "By God I am." Giving up alcohol was the hardest fight he ever had, and he won it that night. In the 1920s and 1930s, boxing was as big as baseball, and when the Lindale lad was 15 years old he won $10 in a prize fight, even though he lost. Watching the contest was a gentleman from Savannah named Dr. B.F Haag who was living in Rome at the time. Dr. Haag had been associated with boxers and the fight game in Cincinnati and knew a hard fighter when he saw one. He took Knowles under his wing and into a period of training. Carl was beating all comers in the Rome area in a very few years, and soon he was "on the road" to seek competition. He was once ranked the seventh Lightheavy Weight boxer in the world. *Ring Magazine*, the bible of the boxing world, described Carl this way: "Carl Knowles may be rough and crude in his style but the 175-pound division would be better off with more like him." He fought the best fighters of his day, and even when he lost, his opponents knew they had been in a fight. He retired from the ring in 1947. Medical science is just beginning to shed light on the effects of head trauma such as Knowles must have endured, but for whatever reason he began drinking heavily and was soon a familiar sight, going from bar to bar until he either passed out or was carried home by a friend or the police. The Rome city buses were even known to pick him up and carry him home to his mother's home off of Shorter Avenue on Burnett Ferry Road, well off their regular route. But it was on the evening in 1964 when Carl Knowles won his biggest victory: he quit drinking and once again became a role model for the youth of Rome. Carl Knowles brought Rome and Northwest Georgia the greatest boxing prestige the area has ever seen. (RFSHF.)

Ish Williams

Being a town surrounded by water, Rome has always been proud of its swimmers. To this day, the Rome High School swim team is competitive at the state level. Growing up in the 1960s and 1970s, the name Ish Williams was synonymous with success in the water. The son of police chief Grover Williams, he grew up swimming in the Oostanaula River with his older brother, Shag, and his younger brother, Kelly, near a sand bar just above the Fifth Avenue bridge. In 1922, Rome opened its first municipal pool and Ish and his friends began to swim there. He later took a job as a lifeguard at the pool and began to dominate competitive swimming in the area. He was spotted by a Georgia Tech representative at a Chattanooga swim meet and recruited to receive a scholarship to Georgia Tech. In 1931, while at Tech he was named to the All American Swim Team. His records in the 50- and 100-yard freestyles lasted some 15 years. He went on to compete against some of the great names of swimming, such as Johnny Weissmuller and Buster Crabbe. Ish was known to say, in his

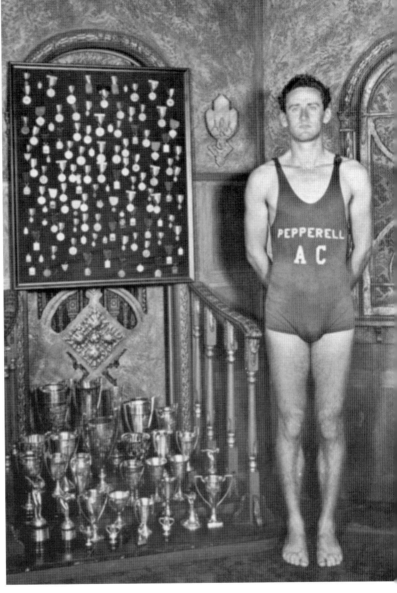

unassuming way, "I didn't beat them, though." While at Tech, Ish was acclaimed as one of the four best collegiate swimmers in America. For several years, Williams rode his motorcycle around the country, competing in swim meets. He once competed in a 12-mile river marathon swim on the Mississippi River. He returned to Rome in the late 1930s, went to work as a commercial printer, and gave much of his time teaching and training area swimmers in Lindale and Rome, including Darlington, Tubize Athletic Club, and Pepperell in the sport he loved so well. He was inducted into the Georgia Tech Athletics Hall of Fame and the Rome Sports Hall of Fame in 1973. (RN-T.)

Ray Donaldson

During high school, this 1976 graduate of East Rome excelled in both basketball and football. In football he played fullback and linebacker, but it was at the University of Georgia that he found his niche at center. He made All-American as both a high school and college football player, and went on to spend 17 years in the NFL, where he was the first African American to start at center. He played as a Colt for 13 years at Baltimore and then at Indianapolis, where he made the Pro Bowl for four seasons. He went on to play for both the Seattle Seahawks and the Dallas Cowboys. In 1996, he retired at the end of the season to Indianapolis, where he coached high school football. He was inducted into the Georgia Sports Hall of Fame in 2006 and into the Rome Floyd Sports Hall of Fame in 2010. Donaldson (left) is pictured here in 1981 with his good friend Nat Hudson, another Rome football standout, at Bob's Body Shop on Shorter Avenue. Like Donaldson, Hudson, a product of West Rome High School, went on to excel at both the University of Georgia and in the NFL.(Courtesy of Bob Moss.)

Mary Josephine "Jo" Dawes Higgins

Until the 1990s, when the effect of Title IX began to pressure high schools and colleges to treat women's sports equally with men, women's sports were rarely recognized as significant by mainstream America. Athletic scholarships for women were unheard of. Local papers, radio, and television rarely highlighted women's sports events. It may be that during football season, men's sports dominate, but times have changed. Women's sports are beginning to be recognized, and it is women like Jo Dawes Higgins that illustrate how sports are not just a man's domain. Displaying a natural ability from an early age, by the time she was 14, in 1942, she won the state championship in badminton. She moved to Rome from Atlanta in 1944, graduating from Rome High School with high honors. She attended Vassar College and graduated from Duke University. She was also a competitive swimmer. She excelled in golf and won the North Georgia ladies title in 1953 and held the Coosa Country Club title in 1961. In 1946, as a junior in high school, Jo was Georgia's second-highest scorer on the basketball court. She was an outstanding tennis player and dominated women's tennis in Rome during her lifetime. She was ranked in the state and south in tennis singles and doubles and holds two national rankings in mother-daughter doubles with her fourth of five children, Dot Cobb. She was also an avid golfer and in 1965 won the North Georgia Ladies Golf title. She accomplished all of these things at a time when women's sports took a back seat to what the men were doing. In 1971, she became the first woman to be inducted into the Rome-Floyd Sports Hall of Fame. (RFSHF.)

Iris Kinnebrew

"Coach K," as she is known, has the ability to combine a fierce competitive edge with a calm and kind demeanor. She enrolled in East Rome High School when it was first integrated in 1965 and was quickly accepted by other students and teachers during what was a tense era. Her personality transcends race and gender, and, once you know her, she is just, well, "Coach K." She was inducted into the Rome-Floyd Sports Hall of Fame in 1984 for her unsurpassed basketball and softball skills at the high school and college levels. The longtime teacher and coach for Rome City Schools continued to excel in softball as an adult and has been a mentor to a tremendous number of Rome's youth throughout her life. (RFSHF.)

Lee Mowry Jr.

Mowry was the favorite announcer for many fans of the Northwest Georgia Textile League. His life was sports. He was the voice of athletics in Rome and broadcast high school football games for many years. The former Marine was a veteran of World War II and Iwo Jima, where he bunked with Ira Hayes for a while. In the late 1940s, he told his friend Willard Nixon that he was going down to spring training in Florida, and Nixon, a former teammate of Ted Williams, gave him a note of introduction. Williams was known for his disdain for reporters, but, because of the note, he gave Mowry a long and memorable interview. Mowry is shown here wearing a hat next to his good friend and fellow announcer Ben Lucas. (Courtesy of Ben Lucas.)

CHAPTER SIX

Outside the Box
Innovators and Rebels

The people we seem to remember the most are often the ones that dare to be different. Some may possess a genius or inspiration not understood by the community at large. They may be considered eccentric, unconventional, or idealistic. Others may be incensed by the unfairness in our society.

In 1963, a group of Main High School students decided to go downtown and eat at the same lunch counters as their white counterparts. The Rome Council on Human Relations, comprised of both white and black adults, was in the background trying to anticipate and ward off any violence.

The same creativity that inspires new ideas can sometimes cause trouble when community norms are challenged. Some, like Charles Craton, are independent thinkers. Some, like Joe Cook, see problems with environmental pollution and look for solutions. Others, like George Anderson, see problems with our political system and work to correct them. Then there are those like Janet Byington and Christa Jackson, who just want to get things done. This chapter focuses on the innovators and rebels, the geniuses and nonconformists, who make up some of our local legends.

Charles Craton

"Thinking outside the box" is his mantra. It has brought him success and gotten him in trouble. Every time you see the cows of the "Eat mor Chiken" ad outside Chick-fil-A restaurants, give credit to Rome native Charles Craton. Raised in an "Ozzie and Harriet" environment in Shorter Heights, Craton attended Darlington and Berry College. After college, he moved to Atlanta and started his own advertising company. In 1990, while visiting Rome and getting a haircut at Herb's Barber Shop, he ran into Bob Skelton, who was working at Berry College's Winshape Program. Skelton referred Craton to Truett Cathey, and, from that meeting, a 12-year relationship with the company and a highly successful "Eat Mor Chiken" campaign was born. In 2002, after 22 years in Atlanta, Craton moved his family back to Rome to give his children the small-town upbringing that was not available in Atlanta.

In 2004, Craton learned about a new "outside the box" business idea from a chance conversation with a Pennsylvania couple, which ultimately led to the creation of a new business that had never before existed in Rome. He opened Entice, a woman-centered adult entertainment business. Rome and Floyd County went up in arms, and Craton was kicked out of the Coosa Country Club and even his own church. He stuck to his guns in spite of the county doing everything in its power to shut him down, and, today, Entice is the largest store of its kind in the Southeast. In reflection on his life experiences, Craton believes that we all face obstacles and trials in life, but you have to fight through them and never give up. He thought outside the box and marched to his own beat. "It's only after being through the storm that we can truly appreciate the sunshine," he says. (Courtesy of Charles Craton.)

Joe Cook

Until the 1930s, Rome's waste went directly to the rivers to wash downstream. The situation is better now, but non-point pollution such as oil and chemicals washing off our streets and parking lots continues to infiltrate the rivers. Since 1992, the Coosa River Basin Initiative has made it its mission to monitor and promote the health of the rivers of the Coosa Valley. In 2004, Joe Cook took over as executive director, serving in that capacity for 10 years. He continues to work for the organization and fights to keep our rivers clean.

The former *Rome News-Tribune* photographer has tried to present an objective view of the importance of our rivers to community health and wildlife, and also to educate the public and our leaders. Since 1995, he has canoed more than 2,000 miles of Georgia's river systems, and has photographed and written about them. The Berry graduate was named in the top 100 influential Georgians by *Georgia Trend* magazine in 2011 and 2013, and continues to lead the fight to protect our waterways. (Courtesy of Joe Cook.)

Main High School Sit-Ins

On March 28, 1963, over 100 high school students, led by Main High School student Lonnie Malone, marched to downtown businesses to protest the city's segregation policies. This photograph by Clyde Collier shows some of the students seated at G.C. Murphy's lunch counter, waiting to be served. After Murphy's, Keith-Walgreen Drug Store, Redford's Variety Store, and Enloe Drug Store denied their requests for service, police moved in, and 62 of the Rome protesters were arrested.

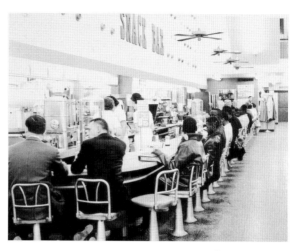

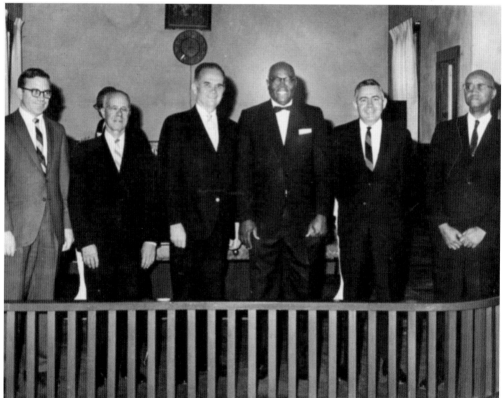

Rome Council on Human Relations

The Rome Council on Human Relations was founded in the early 1960s during the tension of racial integration. Because meetings between different races were regarded as suspicious, the council had to meet secretly to avoid confrontation. Early members of the council included Russell Daniel, Rose and Jule Levin, Franziska Boaz, and others shown in this photograph from the late 1960s. From left to right are Dr. Phillip Greear, John Carter, Dr. John Bertrand, Capus White, John R. Lipscomb, and Charles W. Aycock.

Jule and Rose Esserman Levin
The Levins were members of Rome's Jewish community and were strong supporters of the civil rights movement. Jule, who served as president of the Rome Chamber of Commerce, encouraged local merchants to adopt more progressive attitudes toward their African American customers, and, during the sit-ins of 1962, he worked as a behind-the-scenes liaison between black and white community leaders to ensure a nonviolent resolution. Rose was active in the Georgia Council on Human Relations, an interracial body that helped guide the civil rights movement in Rome. Much of the history of this local movement is recorded in her unpublished memoirs, written in 1988.

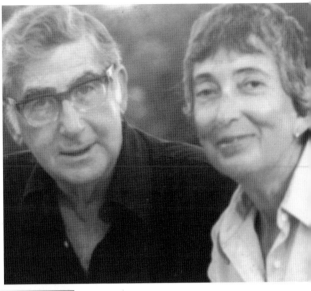

George Anderson
George Anderson does not like corruption. It makes him angry to see politicians blatantly line their pockets. The former Broad Street bookstore owner has taken it upon himself to be an ethics watchdog over our elected officials. If he suspects dishonesty, he will investigate. Coming from a line of lawyers, he makes no bones about taking violators to court. Anderson has his own nonprofit organization, Ethics in Government Group, Inc., which guards against fraud, waste, and self-interest groups in politics. Needless to say, he has been a gadfly to those representing us who are unduly influenced by lobbyists.

Jack Runninger

Because of his honesty about male-female relationships, it is amazing that Jack Runninger's head has missed the "whack" of a rolling pin, and that he has escaped intentional food poisoning for so many years. Runninger has published several hilarious books on his observations of the differences between the sexes. He questions why dishes should be washed when there are so many clean ones in the cupboard, or why clothes should be rehung in the closet when they will be worn again in a few short days. "Mathematical genius" that he is, he calculated that he could save over six valuable hours a year by leaving his cornflakes box on the breakfast table rather than returning it to the cupboard every day. He gets away with what most men only dream of. His many humorous books and newspaper columns belie the seriousness and depth of his dedication to Rome, his adopted hometown.

After finishing his World War II service, where he served as a communications officer on a Navy ship during the Iwo Jima invasions, and his education, he came to Rome to work as an optometrist. His many patients remember him for the quality of his care and attention, but most know him for his tongue-in-cheek approach to life.

By the time the new century arrived, Runninger noticed that many of his friends were "making the transition," his term for passing away. He usually paid a humorous tribute to them based on the human foibles we all possess. This leaves one to wonder who is going to write the glowing tribute to him and leave us rolling in the aisles at the First Methodist Church when he takes his leave of us? He is pictured here with his wife, Helen, commonly referred to in his writings as "What's-her-name."

Calder Baynard Willingham Jr.
It is said that when Calder Willingham wrote *Eternal Fire*, Rome was scandalized. This racy novel was written about a fictional town that was based on childhood experiences and characters he was said to have known while growing up in Rome. This prolific novelist, playwright, and screenwriter is certainly Rome's best-known author to this date. The Darlington graduate wrote *Rambling Rose*, which was also about growing up in Rome, where his father managed the Third Avenue Hotel. The novel was made into a movie starring Laura Dern and Robert Duvall. His most famous screenplay was probably *The Graduate*, which was released in 1967.

Hana Pohankova Roberson
In the mid 1990s, when Hana Pohankova came to Rome with the Czech Republic Olympic kayak team to train, she had no idea she was coming to stay. But there is an attraction here that tends to get hold of visitors to the area. Hana ended up getting married to a local and raising a family, and now calls Rome home. Most folks remember her as the proprietor of Hana's Bakery, located on Spider Webb Drive, that so many came to rely on for pastries and cakes, with its Eastern European flair. She sold her bakery in 2014 to spend more time with her children, but she continues to work in food services and do some baking for her loyal customers. Hana is also a first-class kayaker and competitor who refuses to quit when faced with a challenge. (Courtesy of Hana Roberson.)

Janet Byington and Christa Jackson

Both of these ladies have made their mark on Rome independently, and, when they get together, watch out! They both had children at St. Mary's School, and, true to their natures, became so involved with the education of the students that they ended up working there themselves, even acting as co-principals for a time when the school needed them. They conducted numerous fundraisers, almost singlehandedly built a new school, and made folks laugh and enjoy themselves along the way. They could play "good cop-bad cop," with Byington taking on the role of the heavy when needed. When the two of them put on an event, it is a sight to behold, calling on their numerous friends and coworkers to accomplish more than one would think mere mortals could do in a short time.

Jackson, with her genuine Southern charm, has worked as a special education teacher and store owner in addition to leading St. Mary's School for many years. When her four boys were small, on the Fourth of July, she and her husband, Charles, began parading as a family down the main street of Cave Spring, which over the years has developed into a full-blown parade. She is pictured on the left in a St. Mary's School uniform.

After a time as a paralegal and administrator at St. Mary's, Byington, pictured on the right in a St. Mary's cheerleader uniform, went to work for Rome's representative to Congress, Phil Gingrey. She is constantly on the move and working for public causes. She likes to get things done—be careful not to get in her way when she is moving! (Courtesy of Janet Byington.)

Augustus Wright

Augustus Wright was one of the most interesting people from the Civil War era that Rome produced. At an early age, Wright was judge of the Cherokee Circuit, and he later settled and practiced law in Rome. He represented Georgia in both the US congress and the Confederate congress, even though he was almost lynched at city hall for speaking out in favor of preserving the Union. Though he was a staunch Unionist, he raised a Confederate unit that was known as Wright's Legion, which he commanded for a short while. Wright was active until the day he died. His family found him at the age of 77 lying next to a woodpile near his home in Glenwood, where he had been chopping wood with an axe.

Peggy Snead

For over 30 years, Peggy's was an internationally known "house of ill repute." With its unorthodox beginnings and continued cooperation with local law enforcement, Peggy Snead managed to maintain a balance in her community that few in her profession ever enjoyed.

Legend has it that, anticipating an influx of wounded World War II soldiers at the new Battey Hospital, three city commissioners initially approached Peggy to create a private social setting to accommodate soldiers who were able to leave the hospital campus. The county was dry, and there was no other nightlife or entertainment, so Peggy's was created to give them a place to meet pretty girls and have a drink if they wished. This unusual circumstance began a long relationship between Peggy and the Rome community. She cooperated with the police department over the years, from sharing her cab company radio network and tower to allowing wiretaps in her rooms to assist in criminal investigations. Her support of local businesses was generous. She always paid in cash and tipped handsomely. Her "girls" were well kept and well supervised, but not coerced or bound into employment in any way.

From the late 1940s until the early 1970s, Peggy had a perfect record, with no scrapes with the law, save one that landed her on probation and cost her fines, which ultimately led to the closing of her establishment: underreporting her business income on taxes. An IRS auditor was tipped off to check her laundry bill. Because the linens and towels were laundered daily, the amount of business she did at her "boardinghouse" was calculated on that basis. Despite this incident, she remains even to this day a local celebrity remembered for her signature pink hair and pink poodle, along with countless stories that will be shared with winks and smiles for years to come. (Contributed by Margaret Hollingsworth.)

CHAPTER SEVEN

Notables and Heroes
Heart Stings and Heartstrings

This last chapter features a few reminders of the price we pay for living. Some, like Patty Cook, will bring bittersweet memories from long ago, and other, more recent Romans will show us how to be brave in the face of adversity. Some, like Henry Erwin, were cut off by fate way too early in their experience of life. Some, like Kennedy Williams, smile in the face of adversity, reminding us that life and health should never be taken for granted, but appreciated every day. Others go on to live full lives and leave us with role models to follow. It might not be that folks like Charlie Silvers or Shem Thomas did great things in the total scheme of life, but what they did, they did well, and they were proud of their accomplishments.

Then there are those who guard us every day, our policemen and firemen, and the soldiers who stand ready to put themselves in harm's way to protect us. Finally, there are those like Thelmus McRay, who made the ultimate sacrifice, dying in the service of our community or our country.

Brownie the Depot Dog

Brownie was a stray dog that showed up one day about 1929 at the East Rome railroad depot and immediately captured the affection of the people that worked there. Whether Brownie adopted them or they adopted Brownie is a moot point; Brownie had found a home. He became accustomed to the train schedule and would rapturously meet each train as it arrived. Passengers, especially children, would look forward to seeing the happy mutt with his tail wagging and tongue flapping. He was especially fond of the dining cars and was friends with all the cooks and waiters. He was a special part of the depot until about 1943, when Brownie was attacked by the stationmaster's bulldog and killed. One can only imagine the grief of all of Brownie's friends. The community had a huge funeral that was preached by Reverend Harry F. Joyner. Their affection is still apparent today in the form of this engraved stone, which marks Brownie's final resting spot.

Bertha Hill

In 1946, Bertha Gossett Hill, 28, was arrested and indicted for the murders of her parents and her second husband, Leroy Hill, who mysteriously died on Valentine's Day. At that time, she was a floor manager for McClellan's 5 & 10 (now the home of the Rome Area History Museum). All three victims had suffered from strange stomach ailments. Autopsies revealed the presence of large amounts of arsenic in all three bodies, and they all carried life insurance policies naming Bertha as the beneficiary.

Her first trial, in April 1946, attracted more attention than any other in Rome's history, with 2,000 people in attendance. She was found guilty, but the ruling was overturned on a technicality. Bertha was retried the following year and again convicted, and this time sent to prison for 13 years. In 1959, she was granted the right to a third trial based on new evidence, but the state of Georgia released her from prison instead. She worked in Rome for a while but later disappeared without a trace. Bertha is shown here in her Floyd County jail cell as she stitches a quilt, and at her first trial with lawyers Mack Hicks and Billy Maddox.

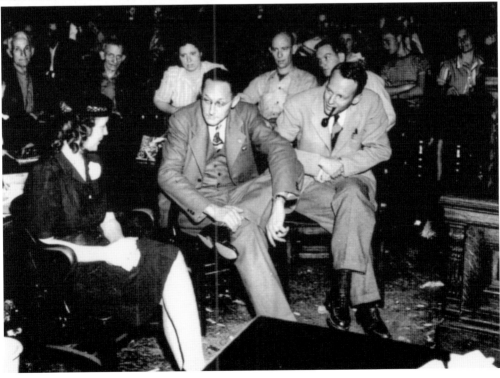

Go to Church Today
Rome's many friendly churches extend a warm invitation to their services. Attend today the church of your choice.

Rome News-Tribune

Rome Weather
Clear to partly cloudy and slightly warmer today and tonight. Previous high: 65; low, 39 degrees.

104th Year—No. 142 Rome, Georgia, Sunday, December 8, 1946 Full leased wire reports of The Associated Press and The International News Service

FOUR ROMANS DEAD OF BURNS IN NATION'S WORST HOTEL FIRE DISASTER

Fire Guts Winecoff In Atlanta, Causing Loss of 127 Lives

ATLANTA, Dec. 7.—(AP)—America's most destructive hotel fire early today turned the 15-story Winecoff Hotel here into a blazing inferno that brought death to 127 persons and injury to at least 100 more.

While scores of guests trapped in the upper part of the building burned or suffocated, other men, women and children plunged screaming to death on the pavements below in the pre-dawn darkness.

Dies in Hotel Fire
Charles Keith, Rome High student who was one of the victims of the Winecoff Hotel fire.

A revised death list compiled late tonight after a check of funeral homes and hospitals which was complicated by the removal of bodies from one mortuary to another after the toll of the disaster at 127.

Of these, 114 had been identified and 13 bodies still were unidentified. It was possible, however, that the total might be changed slightly upon completion of the difficult casualty check.

At daylight, the sides of the tall, chimney-like structure were draped with torn bed-sheets and blankets, marking in grim silence where victims tried to escape. Eyewitnesses told how panic-stricken guests swung from tenth and twelfth story windows on flimsy, makeshift ropes. A few were rescued, but most fell headlong as flames burned away their supports, or they lost their grip.

Others were seen wildly at

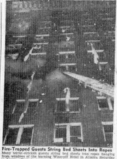

Fire-Trapped Guests String Bed Sheets Into Ropes
Many terror-stricken guests string bed sheets into ropes hanging from windows of the burning Winecoff Hotel in Atlanta Saturday in frantic efforts to escape. Several hours later at least 120 bodies had been removed from the hotel. Arnold Hardy, Georgia Tech student, one of the first persons to reach the scene, took this picture. (AP Photo.)

Rome Youth Bares Horrors of Fire

By COLEMAN PROPHETT

Fifteen-year-old Dick Collier, one of four Rome boys who escaped the fire-swept Winecoff Hotel in Atlanta early Saturday, last night told vividly how he and three companions leaped from their burning fourth floor room to safety on the roof of an adjoining building.

Collier, Charles Gray, Junior Hi-Y President, Roger Sumnicht and Frank Pim were in a room in the rear of the hotel, one floor above the origin of the fire.

"I was awakened about 3:15 by people screaming," young Collier said. "I thought at first there had been an accident, until I heard someone yell fire."

"I slipped on my clothes and shoes and started to open the alarm, but, when we opened the door of our room, all we could see in the hall was a sheet of flame.

"We closed the hall door and Frank Pim knocked the screen from our window. There was an alley about six feet wide between the hotel and the next building, the Butler Shoe Co. Its roof was almost level with our window.

Jumped From Window

"Frank Pim jumped across first and Roger Sumnicht, second, I went third and Charles Gray was just behind me. He stumbled just

(Continued on Page 5, Column 5)

Wrapped Like Indians, Hamils Escaped Fire

(Nine-year-old Richard Hamil, son of C. E. Hamil, Rome, Ga., Boys High School instructor, climbed down a fireman's ladder to safety in the predawn hours this morning when smoke swirled about him and covered his father and the windows of the Winecoff Hotel. Jean Buck, International News Service Staff correspondent, found Richard in the children's ward of Grady Memorial Hospital. He wasn't hurt, he has been comforted by her touch with Buck). Miss Buck asked young Hamil to tell his story to INS. It follows:)

By RICHARD HAMIL

ATLANTA, Dec. 7—(INS)—I am nine years old. The fire was a real experience. It happened too fast. I was not afraid.

My daddy saved my life. And his, too. He wrapped wet, towels around our heads. We looked like Indians.

All of a sudden we heard people

(Continued on Page 5, Column 5)

5 Romans Escape As 2 Others Are Sent to Hospital

Rome families today were suffering a tragic climax to the annual Georgia Youth Assembly in Atlanta as funeral preparations went ahead for four Rome High students who lost their lives in the Winecoff Hotel disaster.

Two other Romans turned victims of the nation's worst hotel fire, while five others considered their good fortune in escaping unharmed from the holocaust.

The dead, all Seniors at Rome High School are:

Charles Wilkes Keith, 18, son of Mr. and Mrs. J. C. Keith, 219 East Sixth Street.

William George (Billy) Walden, 18, son of Mr. and Mrs. E. G. Walden, 322 Avenue A.

Lamar Brown, 18, son of Mr. and Mrs. Dallas Brown, 113 South Broad Street.

James (Buzz) Slaton, 18, son of Mr. and Mrs. H. Grady Slaton, of Chastain Road.

Slaton was the last to be identified. He was found by his father in the mortuary of Awtry and Lovvorn in Atlanta, and no ambulance of Littlejohn-Stevens left late last night to bring the body back to Rome. Identification was made by a tooth and pajamas.

Four other Rome High students,

Fire Victim
Lamar Brown, Rome High student and star of the last City

COAL STRIKE ENDS

108

The Winecoff Fire (ABOVE AND OPPOSITE PAGE)

On December 7, 1946, Carlos Hamil, a teacher at Boys High School, took eight YMCA youth boys and his nine-year-old son Richard to a Tri-Hi-Y Convention in Atlanta. At 3:42 a.m., the fire alarms went off in the Winecoff Hotel, in which they were all staying. Four of the boys, juniors Dick Collier, Charles Gray, Roger Sumnicht, and Frank Pim, were staying in room 430. They escaped by leaping six feet from a window of the hotel to an adjoining roof. Carlos and Richard Hamil were staying in room 1524. Firefighters were able to get a ladder to them and get them out. The other boys were not so lucky. Boys High School seniors Charles Wilkes Keith, Billy Walden, Lamar Brown, and Buzz Slaton lost their lives in that fire, leaving Rome with a sadness that lasts even to this day.

JAMES EARNEST SLATTON
"Buzz"

GEORGE WILLIAM WALDEN
"Billy"

DALLAS LAMAR BROWN, JR.
"Lamar"

CHARLES WILKES KEITH
"Charles"

Patricia Ann Cook

At the end of the 1955 Rome High School yearbook, *The Roman*, is the photograph of a beautiful, smiling Pat Cook, holding an armful of Christmas presents as Miss December. By June 20, 1955, school was out, and the popular and engaging 14-year-old was enjoying some time sunbathing behind her house on East Nineteenth Street while her parents were away. Recent parolee Grady Cochran, 37, later confessed to abducting her from her home and driving her into Bartow County. There, he shot her, wrapped her in a blanket and a chain, and put her body into the Etowah River. He was executed for the murder less than a year later.

Turning through the pages of the 1955 *Roman* and seeing all the young people who went on to lead fulfilling lives leaves a void of sadness felt for this gentle young lady and what might have been, and a sense of loss that lingers to this day. In the book *You Can't Play Outside*, Romans Priscilla Sullins and Connie Baker tell us about the final chapters of the sweet but too-short life of Pat Cook.

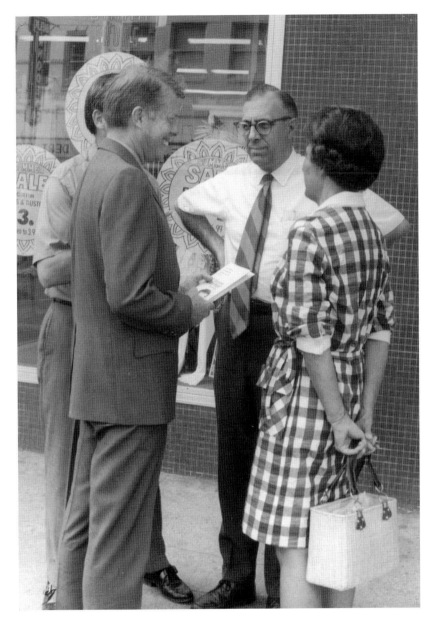

Drs. Claire J. and Barbara Wyatt

Without the Wyatt family, the Rome Area History Museum would not exist as it is. Dr. Claire Jackson Wyatt Jr., or "C.J.," as most folks called him, was a prominent physician for many years and was especially well-loved by the police and firefighters of whom he was so fond. But it was his love and knowledge of local history that enabled him to collect the stories and photographs that now form the core of the museum's collections.

Wyatt's wife, Barbara, was the first Rome physician to specialize in geriatric medicine. His father, Claire J. Wyatt Sr., owned and ran Wyatt's Bookstore, on Broad Street, for many years and was a well-known civic leader throughout his life. The Wyatt family also graciously donated the downtown building that is now home to the museum. Dr. C.J. Wyatt is seen here on Broad Street, talking with Jimmy Carter and his wife, Dr. Barbara Wyatt.

Dr. Ray Corpe

To the community, Dr. Ray Corpe was just "Ray." If one was at the YMCA in the 1980s, they might see him on a daily basis, a man with a towel in his hand, full of energy, and eager to test the water in the Y pool and do his 50 laps. Below, he is pictured with his college swim team, which included Ronald Reagan. When he introduced himself, it was just "Ray." People thought they were talking to a much younger man, rather than a pioneer physician who led the research that has almost eradicated tuberculosis. In fact, he and his team did such a good job treating TB that they worked themselves out of a job. Dr. Corpe was the head of Battey State Hospital, which was so successful that, by the 1960s, they found themselves down to one unit for TB patients. Corpe oversaw the transition of the institution from a medical to a mental hospital. He was much beloved by his staff and patients during his tenure there, and is remembered for his efficiency and fairness, as well as his humility as their leader. (Courtesy of the Corpe family.)

Ray Corpe Ronald Reagan

Diane Harbin and the "Heart of the Community"
Through the Heart of the Community Award, Redmond Hospital recognizes Romans who, through volunteer service, change Rome from being just a "good place to live" to "a great place to live." Diane Harbin fills that bill. The Coosa High School graduate works tirelessly in the community in many roles. She works with the Rome Federated Garden Clubs, has been an advocate for animals through Compassionate Paws, and is a member and former regent of the Xavier Chapter of the Daughters of the American Revolution.

Known for her energy and enthusiasm, she was able to bring together two of her greatest loves, the youth of the community and gardening, with the conception and implementation of Cultivating Young Minds. This is a community garden at the South Rome Boys and Girls Club. The National Garden Club awarded it as the best overall project of the year for 2010. Her involvement in this project led to an invitation to be on the Boys and Girls Club board, where she still serves. She has also, along with her husband, Dr. Banny Harbin, unselfishly raised her niece and nephew to adulthood. (Courtesy of Diane Harbin.)

Kennedy Williams

There are doctors who are heroes, and there are patients who are heroes. It is especially painful when patients are children. Those who meet Kennedy Williams never forget her. Seeing her smiling and friendly face, one would not suspect the adversity this young lady is going through. On the outside, the Rome High School student is a normal teenager. She loves to paint, draw, read, and cheer. She is a member of the Rome High School band and is on the robotic team. But she lost her kidneys to disease at the age of eight, is constantly in and out of doctors' offices and hospitals, and is fighting to stay alive. She is brave, she is unselfish, and she is much too young to face something like this. She is hoping to have a kidney transplant, and her family and friends are actively seeking funds to make sure it happens. (Courtesy of Jackie Jenkins.)

Henry Erwin
Many Romans remember Henry Erwin from 2007, when he owned and operated Henry's Smoke Shack, at 1 Broad Street. He was outgoing and generous to a fault and was an accomplished outdoorsman and artist. The Rome community was in shock when complications from a traffic accident suddenly took Erwin away from his friends and family at the young age of 24. His death is a reminder of the frailty of human life, which is magnified even more by the intensity and energy with which Erwin lived his. We are left with the lingering thought of what extraordinary things he might have accomplished, given all that he had already achieved at such a young age. (Courtesy of the Erwin family.)

Dr. Robert Battey

Arriving in Rome in 1847, Battey went on to become one of the premier surgeons of his time. This Confederate veteran was on the "cutting edge" of a radical new surgery that he developed for removal of ovaries in order to prevent disease. He performed one his first surgeries on Julia Omberg in her home on West First Street, while an angry crowd waited outside to lynch him if his operation failed. Fortunately, the operation was a success, and he went on to perfect his procedure. Battey Hospital was named after him, and he has a monument dedicated in his memory on Broad Street at city hall.

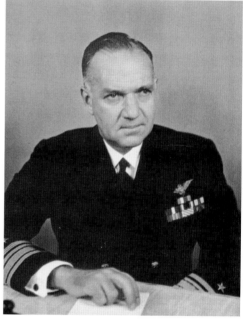

Adm. John Henry Towers

Towers was born in Rome on January 30, 1885, into a family with a proud tradition of military service. Remembered as a studious and athletic boy, it is said that, by the time he was seven or eight, he was navigating the waters of the Oostanaula River in a small boat. After graduating from Rome High School in 1901, he entered the US Naval Academy, from which he graduated in 1906.

Not long after the Wright brothers achieved flight, Towers became a pilot, and he went on to become the "Father of Naval Aviation." He also has a monument next to city hall on Broad Street.

John Shannon Davis

Some people are heroes to others because of the talent they have in a certain area. John Shannon Davis was a true artist of his profession. He was an automobile painter. He started spraying cars in the 1930s, working for local new car dealers. In 1947, he built his own paint shop behind his home in Oak Park, at 115 Cherry Street. He could stripe anything with his striping brush: auto bodies, wheels, whatever. There would never be a run in the paint after he sprayed a car. Here, Davis is seen taking a break to pose for a photograph with his son Johnny.

Later, when Johnny was around 16 or 17 years old, he was helping his father in the shop. They had about three cars they were working on when Johnny said to his father, "You need to advertise. You are two blocks off Shorter Avenue and have no signs. You are not in the paper and not in the yellow pages." Davis looked at his son, pointed to one of the cars, and said, "Right there is my advertisement. If that car leaves here looking great, people will tell others, and if it leaves here looking bad, people will tell others." No matter what business one is in, this wisdom still holds true today. For about two years after he died, people who did not realize he was gone would still call his wife, wanting him to paint their cars. (Contributed by Johnny E. Davis.)

Ben Lucas

From 1947 until 1970, Ben Lucas hosted the "Talk of the Town" show for WRGA Radio. Ben would broadcast from the cupola of Roy's Little Garden, on Dean Street, where the teenagers of Rome could get a Coke and a burger and hang out. Radio was huge in those days, and Ben was the personality of the airways. He later served the Rome City Commission for six years and then went into the real estate business. Shown in the center is Delmus "Little Dee" Franklin, with Ben Lucas on the right. (Courtesy of Ben Lucas.)

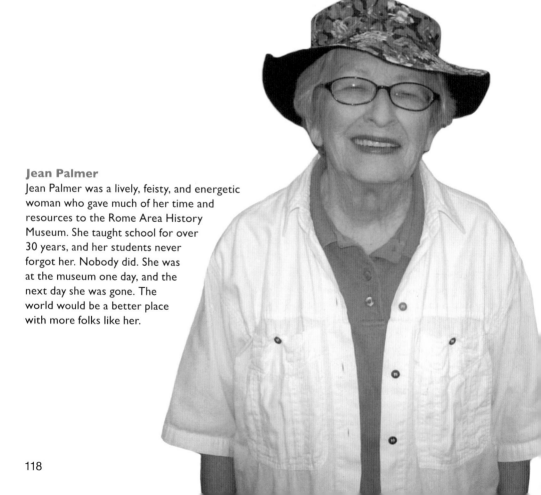

Jean Palmer

Jean Palmer was a lively, feisty, and energetic woman who gave much of her time and resources to the Rome Area History Museum. She taught school for over 30 years, and her students never forgot her. Nobody did. She was at the museum one day, and the next day she was gone. The world would be a better place with more folks like her.

Charlie Silvers

Many Romans of the last half of the 1900s remember Charlie Silvers with a smile. For many years, this tongue-tied character would merrily sweep up Broad Street and visit the merchants as he worked, wearing his red suspenders and pushing his broom and garbage can on a cart. To see Charlie so happy and excited, in spite of what might be considered his poor lot in life, always made it hard for others to feel sorry for themselves.

Shem Thomas

When Darlington School was founded in 1905, its first classroom was a top room of the old fire hall, which is still standing on Second Avenue in East Rome. Its second employee, after the hiring of headmaster Dr. James McCain, was Shem Thomas, who was hired as a janitor and stayed for 40 years. Although he was hired to clean, with his easygoing and nonjudgmental disposition, he became a mentor and role model for the many boys who attended the school. Thomas was regarded so well by teachers and alumni that he earned the school's first honorary summa cum laude diploma when he retired from Darlington.

John Frederick Cooper
In 1861, passions were high and military companies were quickly organizing for the coming conflict. Cooper, a son of "Iron Man of Etowah" Mark Anthony Cooper, was known as a leader in the community and was quickly elected captain of the Floyd Rifles of the Eighth Georgia Regiment. The Eighth Regiment was at the forefront of the Battle of Manassas, and many Rome boys died there. Cooper was badly wounded but survived for over a month before death took him. He died with his pregnant wife by his side. She was Hattie Smith, the sister of Charles H. Smith (Bill Arp). Cooper's oldest son, John Paul, stayed in Rome, became a prosperous businessman and philanthropist, and contributed greatly to the education of Rome's youth.

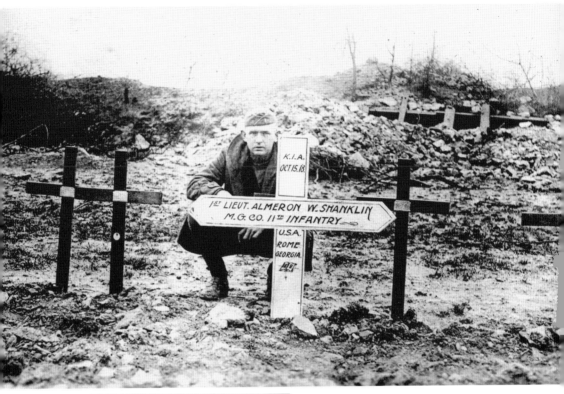

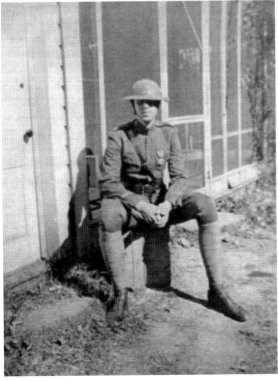

1st Lt. Almeron W. Shanklin

On October 15, 1918, near Cunel, France, Shanklin was ordered to silence a machine gun nest that was putting out heavy fire on the American line. Because his men did not have experience with the 37-millimeter gun and he did, Shanklin ordered them back into the trench. He immediately came tumbling in after them, shot through the head by a sniper's bullet. He was awarded the Distinguished Service Cross for his heroism. In a conversation right before he was shot, he said, "Don't you know I wish it were over? I have a wonderful wife at home and a baby I have never seen." Above, Shanklin's boyhood friend Robert Wyatt is shown visiting his first burial place in France. His body was brought back to be buried in Myrtle Hill Cemetery three years later. The photograph below shows Shanklin seated near his porch at 102 East Fourth Avenue, shortly before being sent overseas.

121

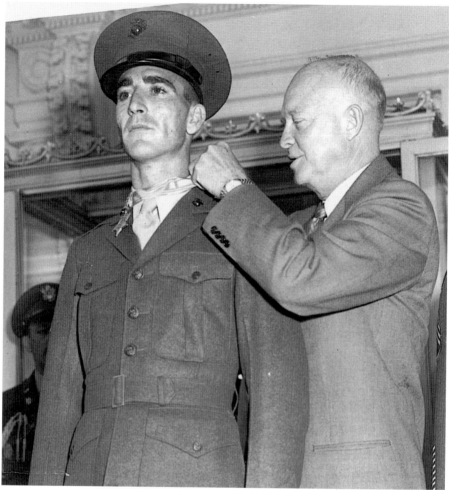

Alford L. McLaughlin

Alford McLaughlin was awarded the Medal of Honor for his bravery in Korea. In 1952, his Marine unit was attacked. During the action, McLaughlin killed 200 of the enemy and wounded at least 50. He and his wife came to Rome in 1952 when he was assigned to the Marine Reserve here. The next year, he was requested to come to Washington, DC, to be decorated by President Eisenhower, as seen here. At the time, he and his wife were living on North Broad Street and she was working for an insurance agency. She asked for a few days off to accompany her husband to Washington and was refused, so she turned in her notice. Even after this, they both still loved Rome and planned to retire here.

There was a lot of envy and jealousy concerning McLaughlin's medal among the Marines and from Maj. Henry Checklou, his commanding officer. Like so many war veterans, McLaughlin had a problem with alcohol. One night, he had been drinking and decided he had had enough of Checklou's harassment, and he went to his house to whip him. He was arrested and turned over to the Marine Corps.

In the summer of 1957, Johnny E. Davis of Rome was at Parris Island, South Carolina, in boot camp. According to Davis, he was with his platoon, standing at attention, when someone called his name. Sometimes, the drill instructors would do things like that to "foul you up." But it was McLaughlin who came around to the front of the formation. "He motioned for me to fall-out and talk with him for a while," says Davis. They had a good long chat about days at the Training Center and about Rome. McLaughlin went on to become a master sergeant before retiring to Leeds, Alabama, in 1972. He died on January 14, 1977, at age 48 and is buried in the Mount Hebron Cemetery in Leeds.

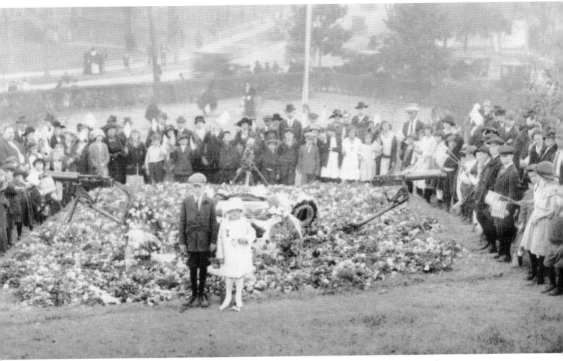

Charles Graves, the "Known Soldier"

In 1922, the last of the World War I dead who had been buried overseas were being brought back to the United States. The US War Department selected two soldiers at random, one to represent all the "unknown" and one to represent all the "known" dead of the war. Graves was selected to represent the "known" soldier. Instead of being buried in Arlington with the Unknown Soldier, Charles Graves's mother insisted that he be buried at the family plot in Antioch Cemetery, on Callier Springs Road. Many citizens, including Graves's brother, felt that Myrtle Hill Cemetery would be a more appropriate place for him. After his mother's death, with an impending injunction against his removal, a group of citizens dug him up and brought him to Myrtle Hill, where he was buried for the third time. On Armistice Day, November 11, 1923, (shown here with Joseph Attaway's son and Almeron Shanklin's daughter in front), thousands of civilians and ex-servicemen assembled at Graves's burial site to dedicate a marble slab memorial in his honor. The tradition of honoring veterans at his grave on November 11 continues to this day. It is certainly an honor to have the "Known Soldier" buried in Rome, but one can only imagine if, as originally planned, he were someday placed next to the "Unknown Soldier" in Arlington Cemetery, where he would be guarded 24 hours a day around the clock. No known photograph of Graves exists.

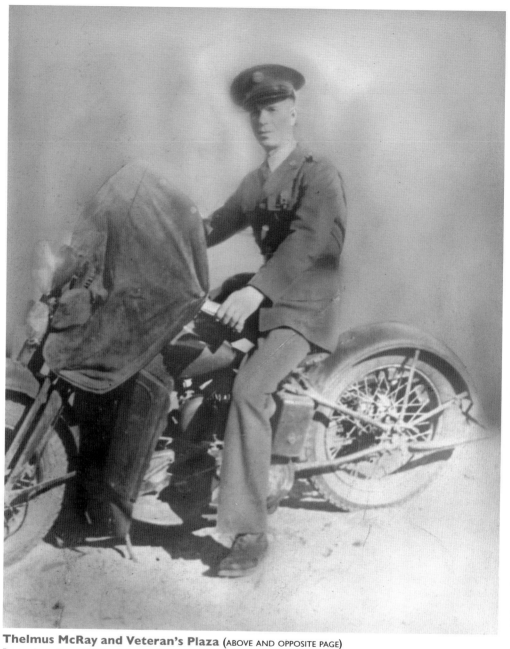

Thelmus McRay and Veteran's Plaza (ABOVE AND OPPOSITE PAGE)
Rome has almost 250 soldiers who gave the ultimate sacrifice for our country, whose names are listed on the Veterans Plaza wall. Thelmus McRay is a representative of the ordinary citizens of Rome who are listed there. He was killed on August 9, 1944, while trying to evacuate one of his wounded men. He was awarded the Army's Silver Star posthumously. Veterans Plaza, between the Forum and the Floyd County Courthouse, is a tribute to those who have served since the Civil War. It recognizes Romans who have lost their lives in the service of our country. They are all true heroes. (Courtesy of the McRay family.)

THE ROTARY CLUB OF ROME

MEMORIAL WALL

Dedicated to the memory of the citizens of Rome and Floyd County, Georgia
who gave their lives in military service for the United States of America during

WORLD WAR I
WORLD WAR II
KOREA
VIETNAM
PERSIAN GULF

"The nation that forgets its defenders will itself be forgotten"
Calvin Coolidge

DEDICATED ON MEMORIAL DAY • MAY 29, 1995

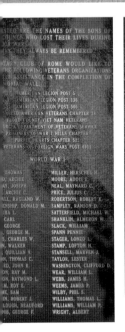

LISTED ARE THE NAMES OF THE SONS OF
...COUNTY WHO LOST THEIR LIVES DURING
...WARS...
...AY THEY ALWAYS BE REMEMBERED

...ARY CLUB OF ROME WOULD LIKE TO
...THE FOLLOWING VETERANS ORGANIZATIONS
...IR ASSISTANCE IN THE COMPLETION OF
...MORIAL WALL:

...AMERICAN LEGION POST 5
...AMERICAN LEGION POST 136
...AMERICAN LEGION POST 506
...ISABLED AMERICAN VETERANS CHAPTER 24
...FLOYD COUNTY VIET NAM VETERANS
...ORGIA DEPARTMENT OF VETERANS SERVICE
...PRISONERS OF WAR 7 HILLS CHAPTER
...PURPLE HEARTS CHAPTER 525
...VETERANS OF FOREIGN WARS POST 4911

WORLD WAR I

...THOMAS	MILLER, HERSCHEL H.
...D., ARCHIE	MOORE, ADDIS L.
...AY, JOSEPH	NEAL, MAYNARD
...ARCHIE C.	PRICE, JULIUS C.
...LL, RAGLAND W.	ROBERTSON, ROBERT K.
...ENSHIP, DONALD M.	SAMPLEY, RANSON D.
...ISH L.	SATTERFIELD, MICHAEL W.
...CARL	SHANKLIN, ALMERON W.
...GEORGE	SLACK, WILLIAM
..., GEORGE M.	SPANN PENNIE
...S, CHARLES W.	STAGER, LONZO L.
...N, WALKER	STAMP, LOFTON H.
...QUILLIAN W.	STANSELL, MARVEN J.
...N, THOMAS C.	TAYLOR, LESTER
...RD, JOHN R.	WASHINGTON, CLIFFORD D.
...ON, RAY M.	WEAR, WILLIAM L.
...ON, RAYMOND L.	WEBB, JAMES H.
...M, ROY E.	WEEMS, JAMES P.
...E, SAM	WILBY, PHIL S.
...N, ROBERT J.	WILLIAMS, THOMAS L.
...LOUGH, BEAUFORD	WILLIAMS, WILLIAM P.
...NIS, GEORGE F.	WRIGHT, ALBERT

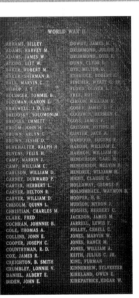

WORLD WAR II

ABRAMS, BILLEY	DOWDY, JAMES M.
ADAMS, HARVEY M.	DRUMMOND, JULIUS P.
ADAMS, JAMES W.	DRUMMOND, OTIS E.
ATKINS, LITT W.	DUNN, CLYDE L.
BAKER, ROBERT M.	DYE, MILTON D.
BAKER, SHERMAN R.	ETHRIDGE, ROBERT G.
BALL, MARVIN C.	FINCHER, WYATT G. JR.
BISHOP, J. T.	FLOYD, OLIVER L.
BOLINGER, TOMMIE B.	FREE, ROY
BOZEMAN, KARON L.	GIBSON, WILLIAM E.
BRASWELL, J. D.	GOBER, JAMES D.
BREDOSKY, SOLOMON M.	GOODWIN, HERMAN C.
BRIDGES, EMMETT	GOSS, JAMES T.
BROOM, JOHN H.	GRISSOM, ROTHIS W.
BROWN, ARLYN C.	GUNTER, JACK A.
BROWN, JESSIE D.	HARBOUR, EUGENE E.
BURKHALTER, RALPH H.	HARDIN, WILLIAM L.
BUYENS, FELIX H.	HARMON, WILLIAM W.
CAMP, MARRIN J.	HENDERSON, CARL R.
CAMP, WILLIAM C.	HENDERSON, MELVIN P.
CARLSON, WILLIAM D.	HENDRIX, WILLIAM R.
CARNEY, DURWARD P.	HICHT, CLAUDE C.
CARTER, HERBERT L.	HOLLAWAY, GEORGE F.
CARVER, BELTON R.	HOLSOMBACK, WAYNON B.
CARVER, WILLIAM D.	HOOPER, H. B.
CHISOLM, QUINN L.	HUDSON, MYRON A.
CHRISTIAN, CHARLES M.	HUGHES, HERBERT G.
CLARK, FRED	JACKSON, JAMES M.
COCHRAN, JOHNNIE B.	JARRELL, LEWIS F.
COLE, THOMAS A.	JOLLEY, CEKELL C.
COLLINS, JOHN E.	JONES, MARVIN W.
COOPER, JOSEPH C.	JONES, RANCE M.
COUNTRYMAN, R. D.	JONES, WILLIAM A.
COX, JAMES R.	KEITH, JULIUS C. JR.
CREIGHTON, B. SMITH	KING, FURMAN
CRUMBLEY, LONNIE V.	KINNEBREW, SYLVESTER
DANIEL, ALBERT E.	KIRKLAND, OWEN E.
BIDEN, JOHN E.	KIRKPATRICK, EDGAR W.

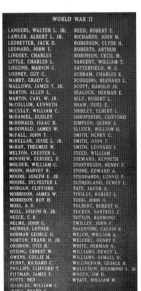

WORLD WAR II

LANDERS, WALTER L. JR.	REED, ROBERT E.
LAWLER, ALBERT L. JR.	RICHARDS, JOHN M.
LEDBETTER, JACK D.	ROBERSON, CLYDE H.
LEONARD, JOHN T.	ROBERTS, ARTHUR
LINDSEY, CHARLES	ROBINSON, CECIL M.
LITTLE, CHARLES L.	SARGENT, WILLIAM T.
LOGGINS, MARVIN C.	SATTERFIELD, W. E.
LOONEY, GUY C.	SCHRAM, CHARLES E.
MABRY, GRADY G.	SCOGGINS, BERNARD L.
MALLOWS, JAMES T. JR.	SCOTT, HAROLD JR.
MARTIN, ALLEN L.	SEALOCK, HERMAN E.
MARTIN, CARL W. JR.	SELF, ROBERT L.
McCOLLUM, KENNETH	SHAW, DUEL E.
McCULLY, WILLIAM C.	SHIRLEY, ELBERT L.
McDANIEL, DUDLEY	SHROPSHIRE, CLIFFORD
McDONALD, ISAAC B.	SIMPSON, QUINN A.
McDONALD, JAMES W.	SLUDER, WILLIAM H.
McFALL, JOHN T.	SMITH, HENRY G.
McKELLAR, JESSE L.	SMITH, JOHN T.
McRAY, THELMUS W.	SMITH, LEONARD I.
MELTON, CHESTER L.	STEED, WILLIAM
MINSHEW, HERSHEL D.	STEWARD, KENNETH
MOLOCK, WILLIAM C.	STOFFREGEN, HENRY P.
MOON, HARVEY R.	STONE, EDWARD A.
MOORE, JOSEPH E. JR.	STUDDARDS, LONNIE P.
MOORE, SYLVESTER L.	SUTHERLAND, DEWEY L.
MORGAN, CLIFFORD	TATE, JACOB A.
MORRISON, JAMES W.	TINSLEY, ROBERT L.
MORRISON, ROY H.	TODD, JOHN H.
MOSS, A. O.	TOLBERT, ROBERT H.
MULL, JOSEPH H. JR.	TUCKER, GARTRILL C.
NEECE, C. R.	TUTTON, RAYMOND
NELMS, JOHN G.	TWILLEY, JOHN F.
NICHOLS, LOTHER	VALENTINE, CALVIN R.
NORMAN GEORGE H.	WELCH, WILLIAM A.
NORTON, FRANK H. JR.	WELCHEL, HENRY E.
ORSBION, OTIS B.	WHITE, HERMAN N.
OTTING, ERNEST W.	WILLIAMS, DEWEY L.
OWENS, COLLIE H.	WILLIAMS, SAMUEL H.
PENNY, RICHARD C.	WILLINGHAM, GEORGE H.
PHILLIPS, CLIFFORD T.	WOLFSTEIN, RICHMOND S. JR.
PITTMAN, JAMES E.	WOODS, JIM D.
POTTS, NED	WYATT, WILLIAM W.
QUARLES, WILLIAM C.	
QUIGG, BYARD G.	

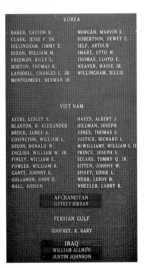

KOREA

BAKER, GASTON R.	MORGAN, MARVIN E.
CLARK, JESSE F. SR.	ROBERTSON, DEWEY E.
DILLINGHAM, JIMMY E.	SELF, ARTHUR
DIXON, WILLIAM M.	SMART, OTTO W.
FREEMAN, BILLY L.	THOMAS, LLOYD E.
HORTON, THOMAS R.	WEAVER, WADIE JR.
LANSDELL, CHARLES L. JR.	WILLINGHAM, BILLIE
MONTGOMERY, HERMAN JR.	

VIET NAM

AYERS, LESLEY S.	HAYES, ALBERT J.
BLANTON, B. ALEXANDER	HILLMAN, JOSEPH
BROCK, JAMES A.	JONES, THOMAS S.
COVINGTON, WILLIAM L.	JUSTICE, RICHARD L.
DIXON, DONALD W.	McWILLIAMS, WILLIAM G. II
ENGLISH, WILLIAM W. JR.	PRINCE, JOSEPH S.
FINLEY, WILLIAM E.	SEGARS, TOMMY Q. JR.
FOWLER, WILLIAM R.	SITTEN, JOHNNY W.
GANTT, JOHNNY E.	SPIVEY, EDDIE L.
GOLLAHON, JOHN D.	WEBB, LEROY B.
HALL, JUDSON	WHEELER, LARRY K.

AFGHANISTAN
JEFFREY JORDAN

PERSIAN GULF

GODFREY, R. GARY

IRAQ
WILLIAM ALLMON
JUSTIN JOHNSON

INDEX

INDEX

AN IMPRINT OF ARCADIA PUBLISHING

Find more books like this at
www.legendarylocals.com

Discover more local and regional history books at
www.arcadiapublishing.com

Consistent with our mission to preserve history on a local
level, this book was printed in South Carolina on American-
made paper and manufactured entirely in the United States.
Products carrying the accredited Forest Stewardship Council
(FSC) label are printed on 100 percent FSC-certified paper.